HAND LETTERING

abcde
fghijk
lmnop
qrst
uvwx
yz

*Lisa Engelbrecht's playful letters made
with chisel tip pen and watercolors*

HAND LETTERING

Simple & Creative Styles
for
Cards, Scrapbooks & More

MARCI DONLEY & DEANN SINGH

LARK CRAFTS
Asheville

Prolific Impressions

Production Staff:
Editor in Chief: Mickey Baskett
Graphics: Karen Turpin
Styling: Lenos Key
Photography: Jerry Mucklow
Administration: Jim Baskett
Indexing: Miche Baskett

LARK CRAFTS

An Imprint of Sterling Publishing
387 Park Avenue South
New York, NY 10016

If you have questions or comments about
this book, please visit: larkcrafts.com

Library of Congress Cataloging-in-Publication Data

Donley, Marci.
 Hand lettering : simple & creative styles for cards, scrapbooks & more /
Marci Donley & DeAnn Singh.
 p. cm.
 Includes index.
 ISBN 978-1-60059-472-4 (trade pbk. : alk. paper)
 1. Lettering--Technique. I. Title.
 NK3600.D66 2009
 745.6'1--dc22
 2009003809

10 9 8 7 6

Published by Lark Crafts
An Imprint of Sterling Publishing Co., Inc.
387 Park Avenue South, New York, NY 10016

Distributed in Canada by Sterling Publishing,
c/o Canadian Manda Group, 165 Dufferin Street
Toronto, Ontario, Canada M6K 3H6

Distributed in the United Kingdom by GMC Distribution Services,
Castle Place, 166 High Street, Lewes, East Sussex, England BN7 1XU

Distributed in Australia by Capricorn Link (Australia) Pty Ltd.,
P.O. Box 704, Windsor, NSW 2756 Australia

Manufactured in China

ISBN-13: 978-1-60059-472-4

For information about custom editions, special sales, and premium and corporate purchases,
please contact Sterling Special Sales Department at 800-805-5489 or specialsales@sterlingpub.com.

Requests for information about desk and examination copies available to college and university
professors must be submitted to academic@larkbooks.com. Our complete policy can be found
at www.larkcrafts.com.

We dedicate this book
to all those who
love letters.

Thank you

Mickey Baskett and
her staff at Prolific Impressions

David Donley

Jane Shibata

Carrie Imai

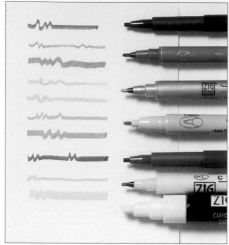

Page 12

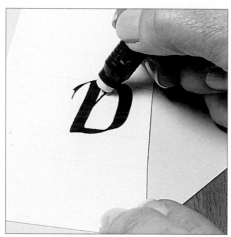

Page 39

Page 45

Table of Contents

Whimsy Alphabet

Brush Italic

Bungalow Alphabet

Preface

All of us have a long relationship with the alphabet and the written word. For me, writing and lettering has been in the spotlight every step and stage of my life. In elementary school penmanship was my absolute favorite part of the day, and I excelled at it. Having mastered long hand, I progressed to Gregg Shorthand, another form of writing that is extremely efficient and much shorter. Along my way I chose

get creative. In this book I hope to inspire you to learn a fun, creative, and beautiful way to express yourself with simple hand lettering. Some people wonder why anyone would want to do hand lettering since it is so easy to do on the computer. I do hand lettering because I find real satisfaction in making letters with my hands and it is a way that I like to pass the time and express myself creatively.

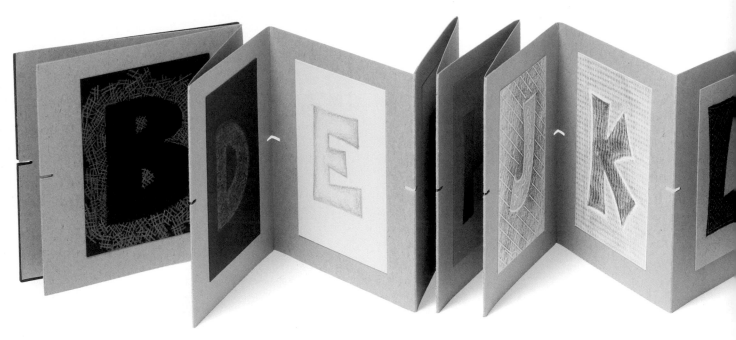

acting as a creative path, using the written word of a script to interpret and make it my own. Now I have embraced calligraphy as my career. I can now see all the parts of my life come together and present a pattern of love for the written word. So needless to say, I love letters and that is why I want to inspire you to love them too.

Although I come from a formal calligraphy background, I just love to loosen up a bit sometimes and

Sometimes I enjoy combining computer-generated images and hand-created images, bringing together the technical and my art.

Hand lettering is not just the writing of words. But it is an art form of writing words beautifully and creatively. Use this book to learn how to use tools and know the basic principles of hand lettering. Practice lettering by using the alphabet examples that are included, and then find your own style and your

particular working technique. Once you are happy with your writing style, you will find that you will often want to use and enjoy your hand lettering skills in creative ways. Do use your skills as much as possible. Leave wonderful notes for people, and to yourself... create your own greeting cards or art...write down your thoughts in an artistic way. You won't be disappointed later as time marches on and you have these wonderful mementos of your life and your experiences.

I want you to come away with the following:
- Knowledge of the tools needed to letter
- Techniques on how to letter quickly
- Ideas to copy or to inspire creativity
- Examples and explanations of techniques
- Confidence to try the examples in the book
- Appreciation for letters
- A recipe to set up your own workspace and supply box

Mixed media altered art alphabet book by Renee Troy

When I am teaching or demonstrating, I get so excited about the subject matter of lettering that I talk faster than any human can take in the information. An advantage of using this book to learn hand lettering instead of attending one of my classes is that you can take in the information at your own pace. The material is presented in a way so that I know you will be successful and at the same time have fun. Since there is a huge amount of information in the forthcoming pages, take your time and enjoy one alphabet or skill at a time.

Marci Donley

Above left, accordion alphabet book in colored pencils by Sylvia Kowal

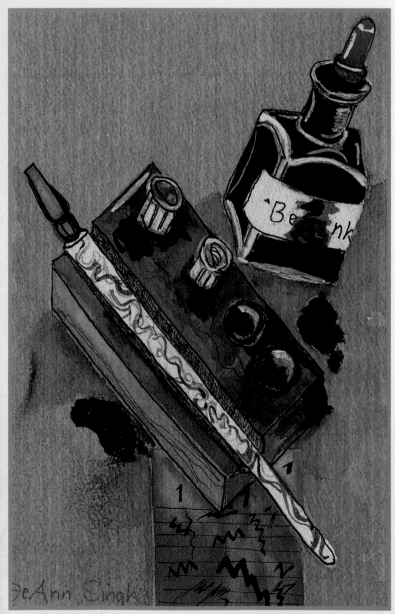

Watercolor painting by DeAnn Singh

Tools & Supplies

There are so many choices for hand lettering tools. In this chapter I have tried to narrow the selection down to instruments and tools that are easy to find and that are the best I know of for casual hand lettering. Buy the best tools you can afford. Some tools are so efficient they almost do the work for you, while other tools of lesser quality may cause you hours of struggle and disappointment. Don't think that because you're a beginner you shouldn't have good tools.

SWEET BABY

WRITING IMPLEMENTS

GRADS

CSA

NYU

...OPNIA SCHOOL OF Culinary Arts

Graduating Class–Winter 2000

Joan

CAROLINE

Sharon

CALLIGRAPHY

HAPPY BIRT

*Bookmarks by
Joan Hawks*

Calligraphy Markers

Markers made especially for casual calligraphy are available in many sizes, styles, and colors. Calligraphy markers have chisel tips. The squared or chisel tip will make it easy for you to create the thick and thin marks that we associate with calligraphic writing. Markers can't be beat for efficiency since there is no need for filling them with ink, and no messy cleanup after you're finished lettering. When purchasing, consider the size of the tips, the color of ink, and the quality of the pen. You will want to have a few different sizes, colors, and tip choices to start with. Calligraphy markers are identified by the size of the nib or tip. The most common sizes you will probably find are from 2mm to 5mm.

Calligraphy markers with dual tips are especially good and economical to have in your toolbox. Dual tip markers have different size tips at each end. A good marker to start out with would be a double-ended marker with a 3.5mm and a 5mm tip.

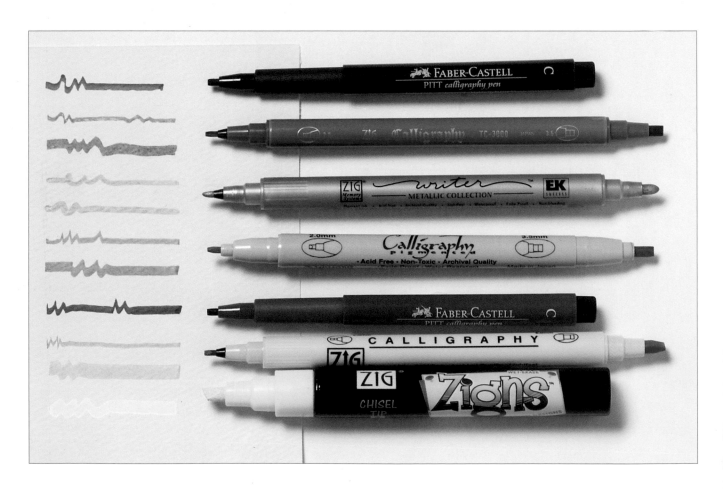

Monoline Markers

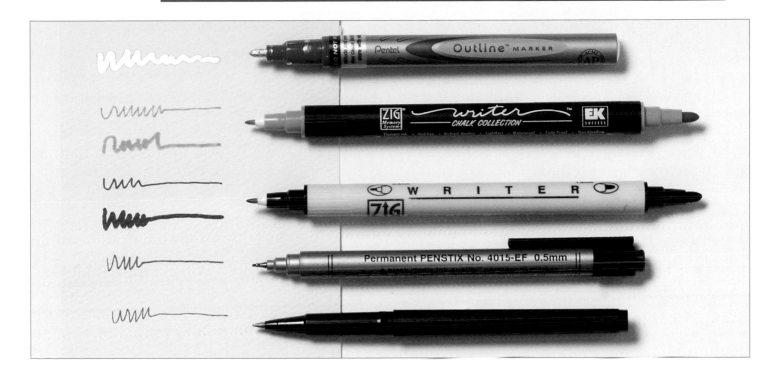

In addition to calligraphy markers, you will need markers that draw a single, consistent line. A ball point is an example of a monoline pen. You can find monoline pens from ultra thin to heavy. Monolines are good for simple block printed letter styles or for some of the creative styles such as *Whimsy*. They are also needed for outlining and for adding decorative touches. Features to notice are the size of the tip, the permanency of the ink, and if the ink is waterproof. If you're using monoline markers next to painted or water-color images, or along with water-based markers, the monoline markers should be waterproof.

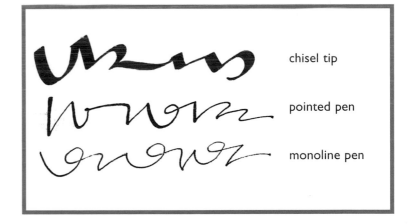

chisel tip

pointed pen

monoline pen

Brush Markers

Brush markers have a fiber tip that looks like a paintbrush tip, and has a constant, even flow of ink. This makes it easier to use than a paintbrush for someone who is not a painter because you don't have to worry about loading the marker with paint. Even the most skilled painter can appreciate the ease and convenience of a brush marker. Brush markers are available in different sizes and different composition brush tips, such as felt or rubber. Some tips are firm and some flexible; some are more like an actual paintbrush. Experiment with a few types to find out which tip works best for you.

Particularly fun to work with are watercolor brushes that you fill with water and touch the brush into any watercolor paint for a very controllable brush. These brushes can also be filled with ink or paint to be used like a cartridge pen. You will need to mix the ink or paint to a consistency that will flow through the brush.

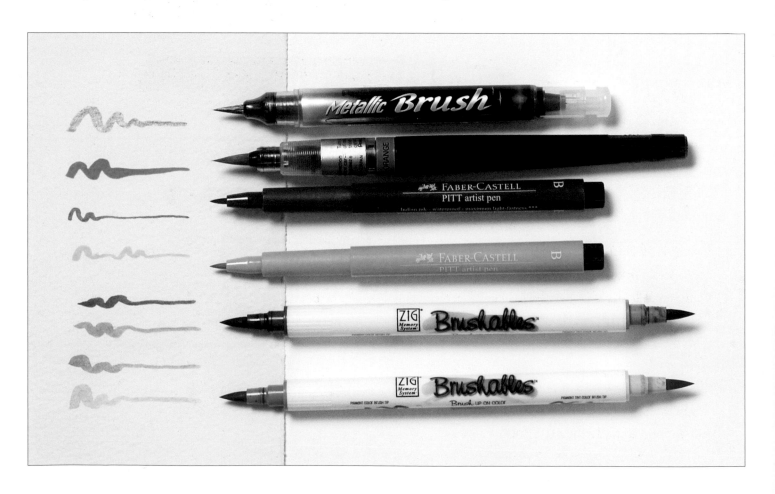

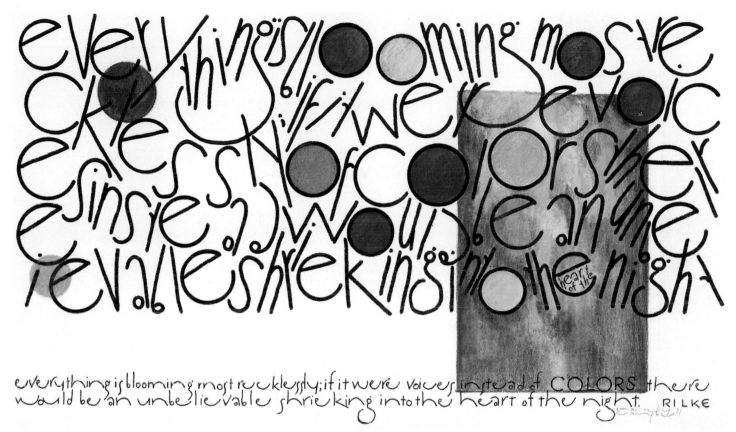

everything is blooming most recklessly; if it were voices instead of COLORS there would be an unbelievable shrieking into the heart of the night. RILKE

Black monoline marker and gouache by Nancy Campbell

Just a thought . . .

Don't be afraid to mix and match. Use numerous colors in one lettering project for extra charm. Use broad pens and thin-lined pens together in the same pieces. Use traditional or informal tools. Produce beautiful decorative letters when you layer your strokes and colors. Decorate your letters using broad pens and then detail them with the smaller tips. Try some specialty inks for extra style.

Brush markers on canvas by Susy Ratto

15

Cartridge Pens & Fountain Pens

Cartridge pens are some of my favorite tools. They are available in a variety of tips, including chisel tip, monoline, and brush. A cartridge, filled with ink gives them the advantage of an even flow of ink. You will find cartridges in many different colors of ink. Some styles have a device to refill the pen with your own specific color ink instead of using manufactured cartridges. Cartridge pens can produce marks that are closest to traditional calligraphy pens.

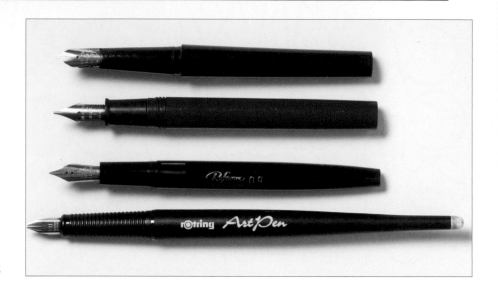

Watercolor painting by DeAnn Singh

Specialty Pens

There are many pens and pencils on the market that can add some spice to your lettering. Available are multi-colored pencils, gel pens, pens that write in two colors, pens for making dots, glitter pens, and more. Keep on the lookout for pens that can add that special unique touch to your work. Many of these are trendy and will come to the market quickly and leave just as quickly, so don't depend on them to be your basic tools.

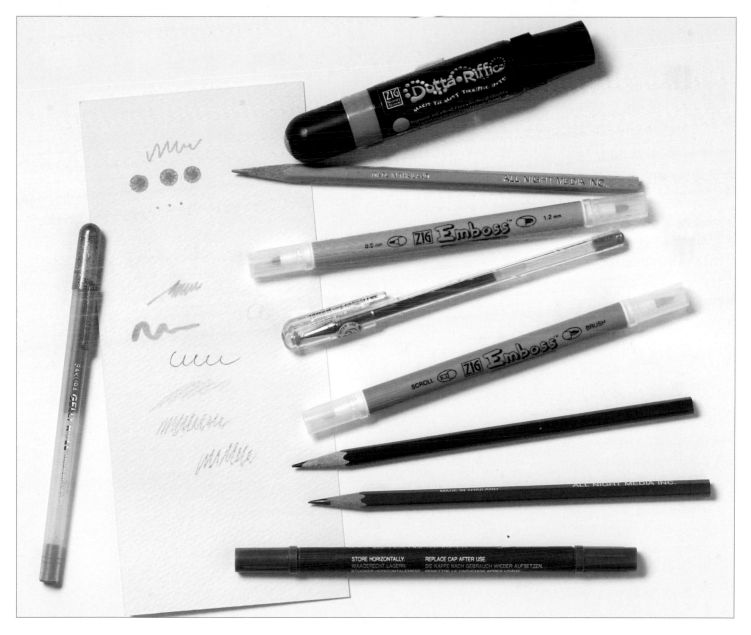

Formal Calligraphy Pens

I am presenting these tools here so that you can notice the difference between formal calligraphy pens and the markers that were used to do the alphabets in this book. Markers mimic the style of calligraphy pens. A professional calligrapher uses a pen holder with the capacity to insert nibs of various sizes and styles. These nibs are filled with a chosen ink type and color. Nothing compares in beauty and crispness to the look of something written with a steel nib dip pen.

Here are the styles of nibs that calligraphers use:

Chisel tip nibs look squared off. They are also called broad edge nibs. Chisel tip nibs are used to form *Italic*, *Uncial*, and *Gothic*, among others. Their thick and thin lines are determined by the size of the nib, the angle of the nib on the paper, and the direction of the stroke.

Monoline nibs have what looks like a little round pancake at the end of the nib. These nibs give an even line width in any direction, much like a ball-point pen, roller pen, or fine-tip marker.

Pointed nibs are used for script-like hands, such as *Copperplate*, *Spenserian*, and their variations. Their thick and thin lines are determined by the pressure you exert and release. Generally when writing with a pointed nib, you use an oblique pen holder to achieve the extreme slant without crippling your hand. You can also use pointed nibs in straight holders for drawing, fine details, and tiny writing.

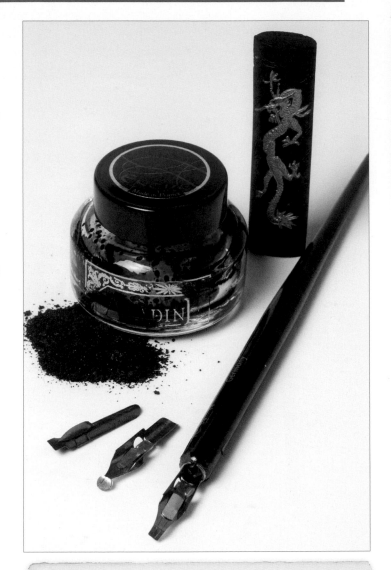

Just a thought . . .

At times, sit down with no intention of coming away with a fully produced project. It is amazing how much less stress you will have when your intention is to play with your tools. Don't even worry about producing something perfect. Enjoy playing and exploring the possibilities.

Above, modern version of ancient manuscript done with calligraphy pens

Right, Roman variation done with calligraphy pen by Joan Hawks

Brushes & Paint

Brushes

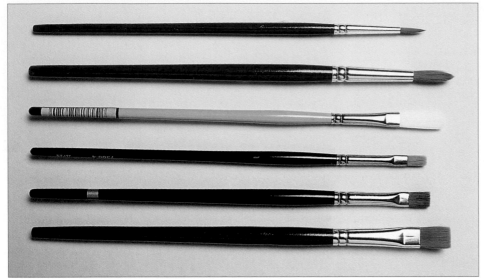

From top: two round tips, a long-haired sign painter's brush, and three shorter chisel brushes all are good for lettering

Brushes are available in chisel tips, rounds, liners, and specialty tips. Although they may be harder to control for the non-painter, they have some distinct advantages. You can create a distinctive, free-flowing style that is not possible with a marker. Brushes also have the advantage of allowing you to letter on many different surfaces by using watercolors, acrylic paints, enamel paints, paints formulated specifically for outdoor uses, and paints for fabric. Not only can you use any type of paint, but you can also use brushes with calligraphy ink.

It's a good idea to experiment with a variety of brushes to find the ones that suit you best. Brushes vary in size and quality. Always buy the best brush you can afford (sable brushes are the highest quality). Cared for properly, a good brush will last a long time and you won't have to replace it.

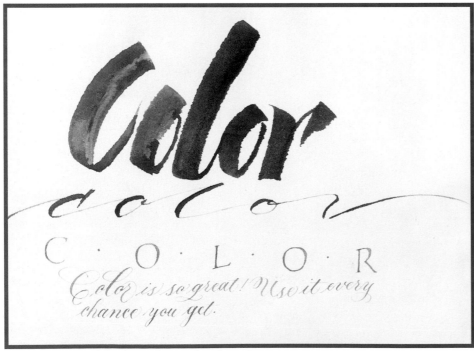

Experimentation with brushes and watercolor, plus various pens

Paints

I prefer **gouache** and **watercolor** for lettering with a brush because I think these mediums produce a cleaner letter, and there is a wider color palette available. Both gouache and watercolor are water-based paints that come in tubes. Watercolors also are available in little pans or pots of color in a palette box (just like the watercolors you may have used in school). The biggest difference between watercolor and gouache is the opacity and density of color. Gouache is more opaque and dense. They vary in quality; buy the best you can afford.

Acrylic paints are also a good choice for lettering with a brush. They have the advantage of being waterproof when dry but are just a bit more trouble to work with. You will need mixing dishes or small containers with lids to mix and store your paints. You will also need to create the right consistency of paint so

that it will flow from the brush. There are mediums available to mix with acrylic paints to help thin them and create a flowing consistency. Acrylic paints are good for lettering on paper and wood as well as some specialty formulas that will allow you to letter on plastic, glass, and metal.

Pictured: Acrylic paint in a bottle

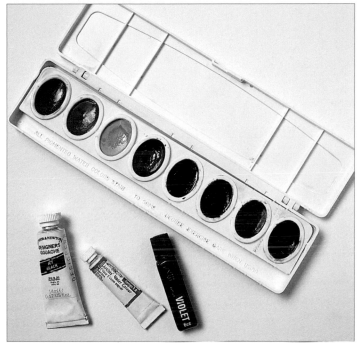

Clockwise from top left: palette box of watercolors, two types of tube watercolors, gouache

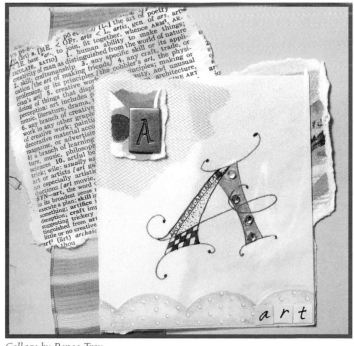

Collage by Renee Troy

Fun & Unusual Tools

Making letters and borders with unusual tools can be fun and the results are surprising. Be creative by trying out some things you may have around the house. Following are some examples of items found in the home that can be great lettering tools.

Dental Stimulator

This unusual writing instrument is made from wooden gum stimulators. Dental stimulators are wooden toothpicks that are joined together and can be found at your drug store in the dental aisle. You can break off a section with the number of picks needed for the width of the letter you desire. After breaking off the section, attach it to a handle such as a tongue depressor, a craft stick, or some other type of small handle. Dip the end of the picks in paint or ink. Allow the picks to become saturated. Start writing! They create a multi-line stroke.

The picks were loaded with black ink. Colored pencils were used to fill in between the lines.

Here, the picks were loaded with paint colors.

All examples by Carrie Imai

For this word, half of the picks were dipped into green ink and the other half were dipped into purple ink.

Cosmetic Sponge

Cosmetic sponges are smooth and can easily be cut. You can use these sponges with ink or paint. To use the sponge to make wide letters, dip the wider square end of the sponge into ink or use a brush to apply watercolor paint to the sponge. Pull flat strokes to form letters. Try dipping each side of the end into a different color or brushing on two or three colors. Outline the resulting letters to make them pop.

Make monoline letters fast and easy by using the thinner end of the make-up sponge. Dip the sponge edge into ink or paint and use it like a rubber stamp, using a light pressing motion.

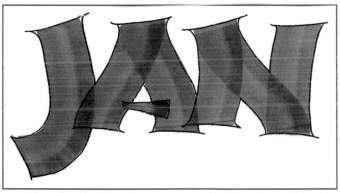

The wide end of the makeup sponge was loaded with two colors of ink then pulled to write the letters. The black outlining on the letters helps to define them.

A kitchen sponge was cut into a rectangular piece. The piece was dipped into two colors and used in a stamping motion to create the block letters. A monoline marker was used to outline the letters.

Kitchen Sponge

A kitchen sponge will create letters with a great texture. Cut out letter shapes from the sponge or cut a rectangular shape so that you can make block letters. Dampen the sponge piece (not too much), then dip it into ink or paint. You can use two or three different colors if you brush the color onto the sponge. Blot off the excess and use like a rubber stamp to make letters. You shouldn't press too hard or you will lose the sponge texture. Outline the letters to help define them.

The narrow edge of the makeup sponge was dipped into two colors of ink and stamped to create these letters.

Papers

Choosing the right paper is the starting place of a project. The quality of paper you use makes a statement about your work. When you choose a paper for your project, it's important to consider how the item will be used. Will the paper be folded? Does the piece need to be sturdy enough to stand? Will it be handled a lot? Answer these questions so that you can choose the size and weight of paper appropriate for your needs.

Start with **graph paper** for all your practice lettering. The important connections that you will make by seeing the boxes on the paper and forming your letters with those measurements in mind will help you learn letter proportions. The straight lines of the graph will make it easy for you to get in the habit of writing straight. You can use graph paper for your finished lettering, then copy it on a photo copier onto good paper.

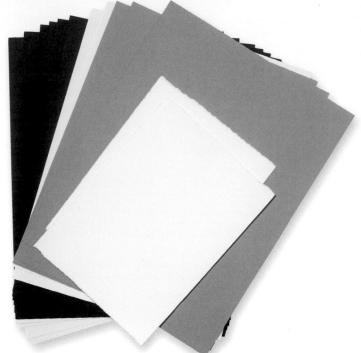

Writing papers

Papers to use for cards, art, scrapbooks, and gifts:

- **Watercolor paper** in weights ranging from 90 lb. to 360 lb. and smooth surface (hot press) or a rough texture (cold press)

- **Vellum**—Great because it is translucent, allowing you to place lined paper underneath or to trace over a lettered example

- **Parchment**

- **Fine writing papers**

- **Cardstock and cover weight papers**

- **Scrapbook papers** that are available in a variety of cut sizes

- **Pre-folded cards and envelope sets**

- **Accordion fold cards and books**

- **Tags** in a myriad of colors, textures and sizes

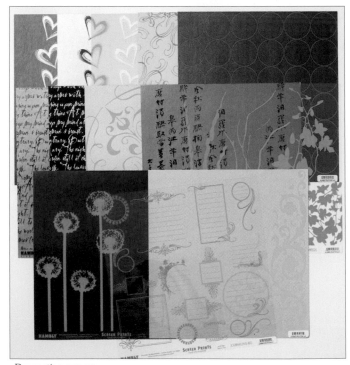

Decorative papers

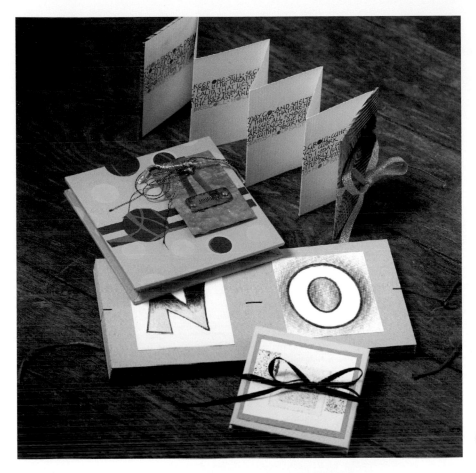

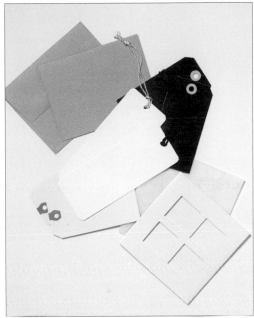

Blank tags and cards

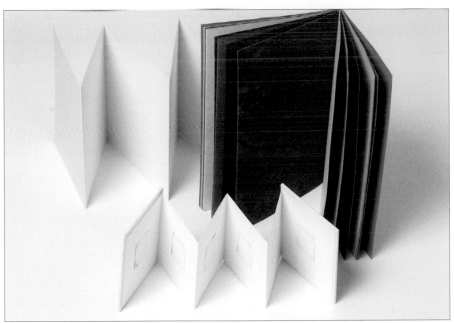

Pre-made books and accordion cards

TIPS

Don't forget other surfaces that can be used for your lettering projects. Wood, metal, fabric, and plastic can all be used; but be sure you are using a pen and ink that is appropriate for the surface.

Computer generate your own paper designs. Decorate a sheet of paper with your writing, stamping, drawing, child's artwork or other images you like. Scan the paper into your computer and print it out. Use this design paper as background for cards, memory books, bookmarks, and tags. Not only will you have unique, personalized paper, but you will save time and money at the paper store.

Measuring Tools

You will need measuring tools to help in drawing guide lines on your paper as well as measuring for cutting.

- **T-square**—This tool will aid in drawing guide lines. Measure with a ruler and make tick marks on one side of your paper, then use a t-square to line across the page.

- **Clear Ruler**—The see-through quality comes in handy when measuring between letters.

- **Metal Ruler**—Choose a metal ruler with a cork back. Use the metal ruler as a straight edge to cut against with a craft knife. The backing keeps it from slipping.

- **Protractor**—This is helpful in determining angles. You will need to draw slanted guidelines on your paper when lettering in italic. A protractor will help you draw lines at just the right angle.

- **Graph Ruler**—This ruler is helpful for keeping measurements square. It works well when practicing on graph paper.

- **Rolling Ruler**—This tool is a terrific time saver for drawing guidelines on your paper. A rolling ruler is a plastic see-through ruler that has a rolling bar and two small wheels. It can be found in various lengths.

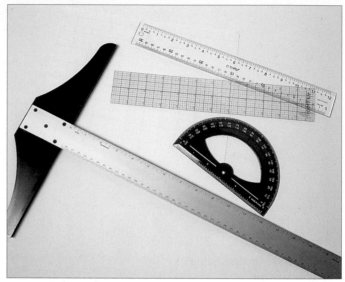

From top: clear ruler, graph ruler, protractor, t-square

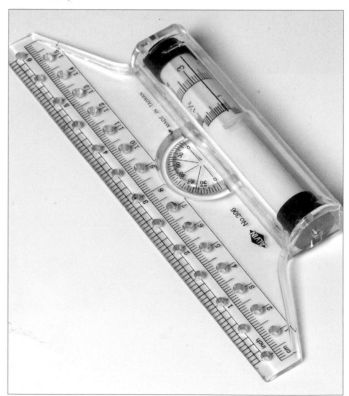

Rolling ruler

How to Use a Rolling Ruler

Making Circles

A rolling ruler will make a circle that is double the length of the ruler.

1. Place a pencil in the first hole at the left side of the ruler or at the 0 point on the ruler (see photo 1).

2. Place another pencil in the hole along the ruler that is the radius measurement for the size circle you wish to make. For example, if you wish to make a 4-inch (10.2 cm) circle, place the second pencil into the hole at 2 inches (5.1 cm) (see photo 2).

3. Keep the pencil that is in the 0 hole stationery while you pull the other pencil around in a circle (see photo 3).

Making Slanted Lines

1. Start by ruling parallel lines down the paper, spacing them as needed.

2. Place a dot at the approximate midpoint of the center line (see photo 4).

3. Using the protractor section of the ruler, line it up with the ruled line, placing the center of the 0 degree line at the dot.

4. Decide what slant angle that you need, usually 5° for italic. Make a mark on that degree

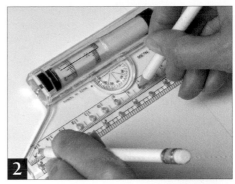

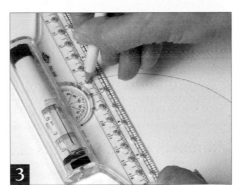

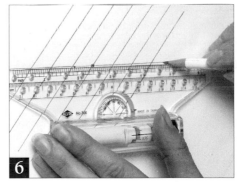

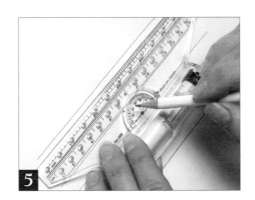

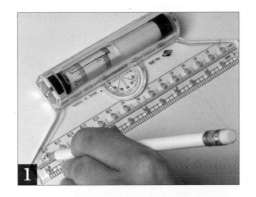

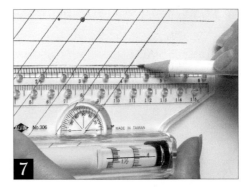

number using the protractor (see photo 5).

5. Align the ruler between the two dots and connect them with a straight line (see photo 6).

6. Move the ruler along, up or down, continuing to draw parallel lines (see photo 7).

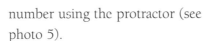

Cutting Tools

Using the right tools for cutting is important when you are making projects such as cards, scrapbooks, or other gifts. My best advice to you is always use sharp tools. Precision cutting tools will make your work look professional. Here is a list of a few of my favorite cutting tools:

- **Craft Knife and Metal-edge Ruler**—Use a craft knife against a metal-edge ruler with a cork back to cut precise, straight lines. Change blades when they become dull so that you don't ruin your artwork by shredding the edges.

- **Self-healing Mat**—When using a craft knife for cutting, always use a mat underneath. A cutting mat protects your work surface, keeps the blade sharp, and helps to keep the blade on a straight course while cutting.

- **Scissors**—Most paper cutting is not done with scissors because it is hard to cut a straight edge with them. Use sharp craft scissors for general cutting and for cutting embellishments such as ribbons and decorative fibers.

- **Tweezer Cutters**—This handy tool, with surgically sharp scissors on the ends of tweezers is borrowed from the medical field. While they are not a necessity, they are nice to have.

- **Decorative-Edge Scissors**—Decorative scissors come in a variety of designs for adding special edges to cut paper. When using decorative-edge scissors, it is helpful to draw a straight pencil line on the back of your paper to use as a cutting guide. When cutting, don't cut to the very ends

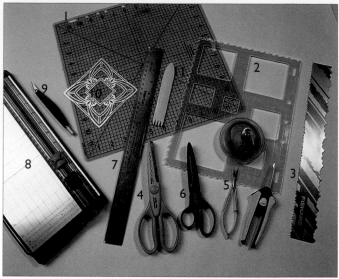

1) Cutting mat; 2) Plastic template shape cutter; 3) Decorative edge ruler; 4) Scissors; 5) Tweezer cutters; 6) Decorative scissors; 7) Metal ruler; 8) Paper trimmer; 9) Art knife: 10) Metal cutting template; 11) Bone folder

of the scissors points. Stop cutting just before the end, realign the motifs, and continue.

- **Paper Trimmer**—A paper trimmer with a sliding or rotary blade is a must for cutting perfectly straight edges.

- **Shape Cutters**—Templates and other devices are available for cutting shapes and windows in cards or scrapbook pagers.

- **Decorative Edge Rulers**—These help you create different types of torn-edge designs. Simply place the paper under the ruler, then firmly hold down the ruler while you lift the paper to tear the edge.

- **Bone Folder**—A bone folder is used to score paper for sharp folds. This tool is a must for card-making. It can also be used to score a piece a paper for tearing.

Decorative Accents

There are wonderful items out there for adding glitz and glitter to your lettering projects. Have fun decorating your projects with all the unique and fun products that are available to you. Here are some of my favorite items to use:

- Glue pens
- Glitter glue
- Glue pen and foil
- Hot foil pen
- Glitter adhesive tool
- Iron-ons
- Ribbons
- Stickers
- Die-cut paper designs

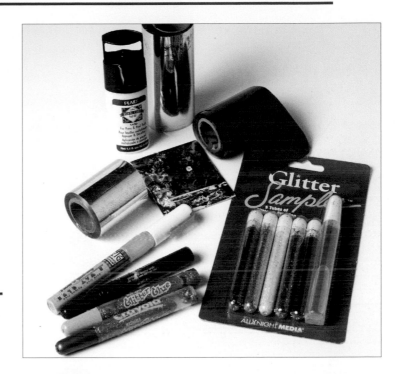

Light Box

Light boxes are available in various sizes, prices, and efficiency levels. Determine how much lettering you intend to do and buy appropriately. Consider the price, size and portability that work for you.

The advantage of the light box is that you can use heavier paper for your lettering without having to draw guidelines on the paper. A light box is a great time saver in this instance. Simply make a guideline sheet that you can place under the paper you are lettering. When used on top of a light box you will be able to see the guidelines through the paper, making it easy to letter even, straight lines. This guideline page can be used over and over. You can also use your light box to trace shapes and artwork to add to your calligraphy.

Making an Inexpensive Light Box

- Perhaps you don't want to invest in an expensive light box. They can get quite pricey. Making your own light table is easy and inexpensive. Purchase an inexpensive under-the-counter florescent light and an 18-inch (45.8 cm) x 30-inch (76.2 cm) x 3/16-inch (7.6 cm) thick piece of translucent

white plastic. These materials are available at your favorite home improvement or discount store. Set the light face up on your table and lean the plastic on top of it so it's at a slant. Do your lettering in the lightest area of the plastic.

- If you have a glass table, put a light source underneath it and create a light box instantly.

Ready To Letter Box

Let's face it, if you have a comfortable work area and a box of supplies ready, you are more likely to spend time lettering. Your house might not have a space that you can permanently dedicate to your lettering needs but you can certainly have the necessary tools and other lettering supplies in a box that is ready to grab when you need to create a card, tag, sign, or memory page for an upcoming celebration. Even if you have a craft room or a studio in your house you should have your lettering supplies stored in one place, all together for easy access.

Here are some of the items to include in your Ready-to-Letter Box:

- Favorite lettering pens and markers in a variety of colors

- Blank tags, cards, envelopes, cardstock, watercolor paper, drawing paper

- Gold or silver highlighters

- Gel pens in colors for decorating letters

- Pencils

- White eraser

- Metal edge ruler—for measuring and cutting

- Bone folder

- Toothpicks & cotton swabs

- Tracing paper

- Graphite transfer paper

- An assortment of decorative papers

- Glue stick, white glue, double sided tape, glue dots, pop dots

- Fibers and ribbons

- Craft knife

- Self-healing cutting mat

- Charms, do-dads, embellishments

- An attractive box

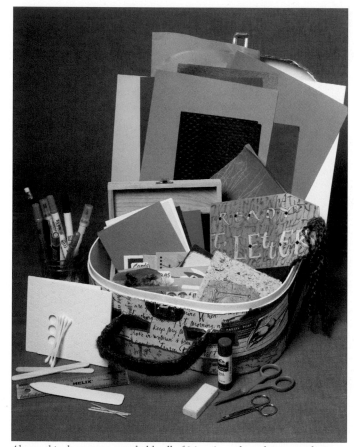

Above, this decoupage case holds all of Marci's ready-to-letter supplies

Right, accordion window shade by Sylvia Kowal shows off various writing styles

Sunshine

Express

Stimulate

LAUGH

Inspire

LISTEN

TEACH

Satisfy

stimulate

inspire

CHERISH

LOVE

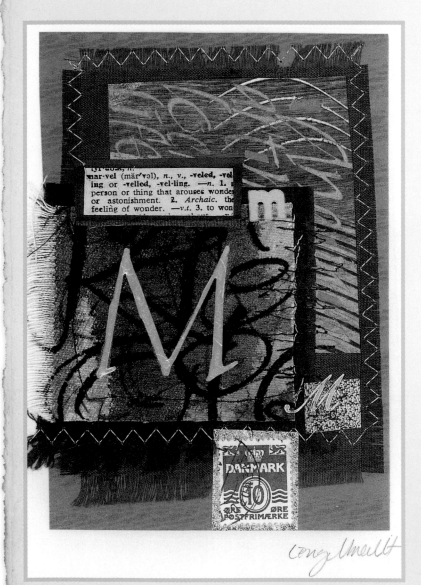

Collage by Lisa Engelbrecht

General Information

... or how to get started

Here is some basic information that will help you get started on your hand lettering adventure. This chapter includes tips and techniques for successful lettering. Once you have read this, you will be ready to move on to choosing one or more of the alphabets to practice and master. Then, before long you will be able to create your own invitations, greeting cards, gift tags, or even pieces of art.

Anatomy of a Letter

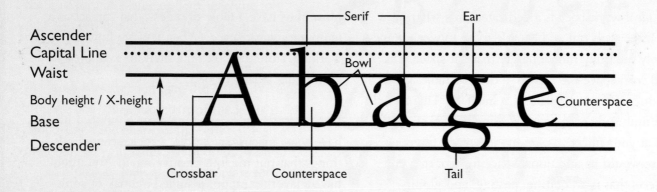

Ascender—the uppermost part of the extenders, such as on a d or l.

Base—the line on which the letters sit.

Descender—the part of a lower case letter that goes below the body, such as on the j or g.

Ductus—the stroke order for constructing a letter.

Extenders—both the ascender and descenders, because they extend beyond the body height.

Horizontal Stroke—the cross strokes, such as the cross of or crossbar of A or E

Leg—A stroke that extends downward at less than 90° is a leg, and seen on the letters k, K and R.

Skeleton—the basic underlying structure of the letter.

Stem—the main down stroke of a letter.

Waist—the line that marks the top of the a, c, x, etc.

Weight—the boldness and overall light and dark of the letterform.

X-Height—the height of the body of the letters.

Preparing the Paper

The first step is picking out the paper and preparing it. Pick out the proper paper for the end use of the piece. For instance, if you want to reproduce your work in only black and white, then graph paper will do. The work done on graph paper can be reproduced since the blue will fade away along with any white-out corrections, making it easier for you to letter straight and create letters with good proportions. Take it another step and scan it onto your computer so that you can fix it up and make it any color you want. If you want a fully colored original piece, consider a good quality of paper. The weight and type will be determined by how you wish to use it.

Here are some questions to be considered when choosing paper:
- Will it be copied or scanned?
- How many do I need of the same image?
- What amount of time and money do I plan to invest in the project?
- What is the purpose of the project you are doing?
- Will it need to be folded?
- Am I going to attach it to something else?
- What size will the end product be?

Consider the Size of the Project
For a miniature project you will obviously need a smaller amount of paper than you would need for a large piece. I always advise getting more than you need rather than less than you need, or even exactly what you need. This allows for mistakes or a change of mind. Be prepared with enough paper if you get an inspiration. Even when everything is going along fine, you might think of something even better and wish you could re-do what you have done. Don't cut the paper to the correct size. Make it larger and write in the middle. It gives you room for error. If the line goes longer than you thought, you can just change the margin lines.

Choose Papers for Combining and Layering
When making cards and scrapbook pages, it is fun to layer and combine papers. When using papers together, consider this rule—five colors, two weights, and texture.
1. Choose one color for your background color.
2. Pick two additional papers of the same weight in colors that coordinate with the background paper, one darker one lighter.
3. Add contrast with the fourth paper by choosing a paper with texture or transparency. It should be very dark or very light.
4. The last paper should be a differnt color from all the rest and stand out because of it.

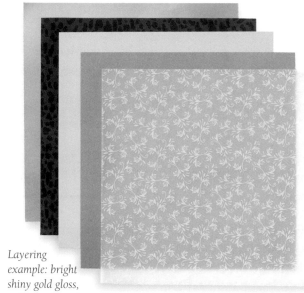

Layering example: bright shiny gold gloss, animal print velvet texture, light green, sage green, and printed vellum

Make Guidelines on Your Paper
The next thing you should do after choosing your paper is to draw guide lines on it using light pencil lines. I also recommend penciling in letters whenever possible. You will letter over these penciled letters and erase any marks that show. If you can't line directly on the paper, you could place a page of lined guidelines *under* your paper, perhaps using the paper on a light box if it is too thick to see through. Once you make a lining sheet keep it to re-use in other projects.

Correcting Mistakes

I am great at correcting mistakes because I have so much practice. I was taught to strive for perfection and I do believe in doing things right the first time. I have also learned that mistakes can't always be avoided. Rather than starting over when a mistake has been made, I have developed ways of correcting my mistakes to save what has been done.

1
Erase

Use a white eraser for best results. This will work with some markers, depending upon the paper you use. Erasing doesn't usually work with paint. Cut some erasers into little pointed pieces for small areas.

2
Cover it up

Create a design element to place over the error that will make it seem like a part of the original design. Make it three-dimensional to make it more purposeful.

3
Scrape, burnish, & re-write

 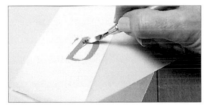

1. Use a craft knife to scrape off the error.

2. Burnish the paper to smooth the surface.

3. Rewrite.

4
Cut & paste

This technique works best for black and white reproduction. Simply rewrite the word on another piece of paper, cut it out, and paste it over the mistake. The piece can be copied without the corrected pasted in part showing.

5
Scan it

Scan your piece into your computer, fix it, and then print it out. You will have a great design, but your final won't be original. Sometimes this won't matter.

6
Start over

When all else fails, start over. But, be sure to keep the rejected piece for use in future projects.

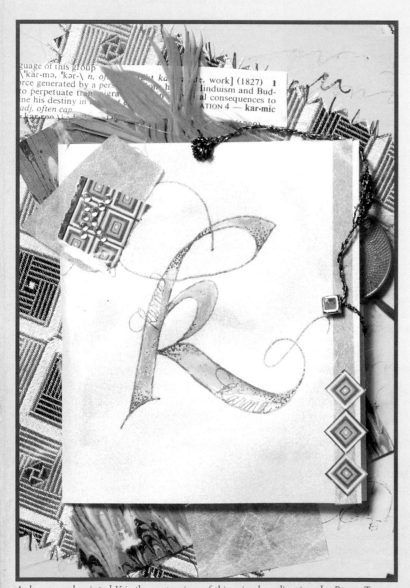

A drawn and painted K is the centerpiece of this mixed media piece by Renee Troy

Decorating Techniques

Your plain and simple lettering can be enhanced with a variety of decorative techniques. The decorative effects can be as simple as using different colored markers, or as involved as decoupage. On the following pages I offer you some creative ways to decorate your lettering and your projects.

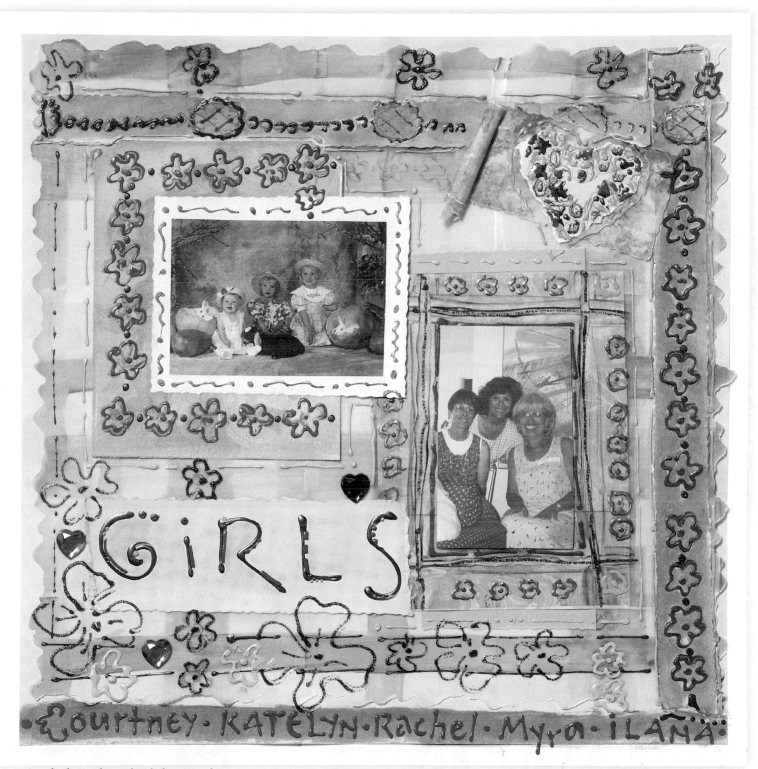

Scrapbook page lettered with dimensional paint

Character Marks

Character marks are scribbles that almost resemble writing. They are made in one continuous line, crossing and moving in upon itself to create a small design that looks almost like a Chinese character. Try these marks as independent flourishes to accent your lettering design. Adding dots creates cohesion in the design. This is a great way to warm up and become more fluid.

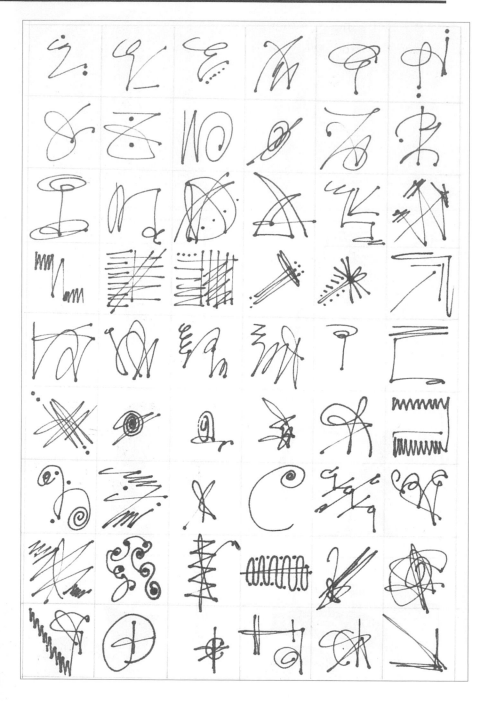

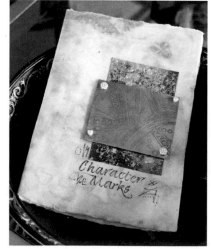

Left: This book contains page after page of decorative marks. The book was made to practice various pen widths and line strokes, as well as being used as a reference for letter or page decorations. The cover of this book is made with handmade paper, a scrap of decorative paper, and a brass plate.

Dimensional Paint

Dimensional paints are fun to work with and add dimension that can really perk up your lettering. I love to use them for outlining, defining, or for adding decorative elements. Dimensional paints can also be used to hide a multitude of mistakes.

Dimensional paints come in plastic squeeze bottles that have applicator tips so that you can use them right from the bottle. They are available in an array of colors and textures such as shiny, metallic, glitter, neon, and pearl effects. You can find them at most crafts and art supply stores. Please follow the manufacturer's instructions regarding curing time.

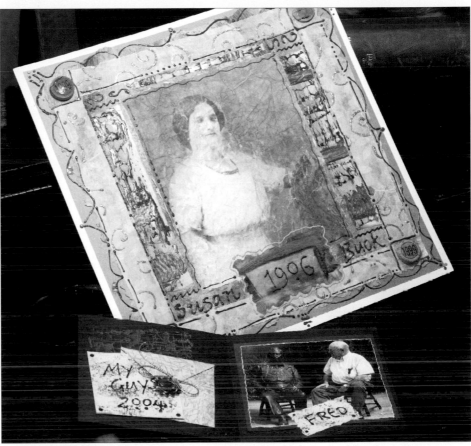

Dimensional paint has been used for the lettering and to decorate the pages of this photo album and scrapbook page.

Tips for Using Dimensional Paint

- Hold the bottle just slightly above the work. Use an even pressure on the bottle as you form the letters or design.

- Work with the tip of the bottle ahead of the paint. Pulled strokes look much nicer and are easier to execute than pushed strokes.

- Lift the bottle straight up as you exit from a line or dot. Watch to be sure the paint separates from the bottle.

- Wipe the tip of the bottle frequently while you work.

- Have cotton swabs and toothpicks handy to fix any unintended paint drips.

- The paint will flow together if lines of paint are placed too close together.

- Dimensional paint should be the last step to your project because it needs drying time before you touch it.

Rubber Stamping & Heat Embossing

Rubber stamps are effective decorative accents to your projects, and can be added quickly and easily. There is an endless variety of stamps for any occasion and ink pads of every color.

Heat embossing is used with rubber stamps to give them dimension and texture. Rubber stamp the design onto your surface using embossing ink, sprinkle the ink with embossing powder, and heat it with a heat embossing tool to give the powder dimension and shine. If you don't wish to use a stamp, you can write the letters with a pen that contains slow-drying ink or a special embossing pen. The writing is then sprinkled with the embossing powder and heated.

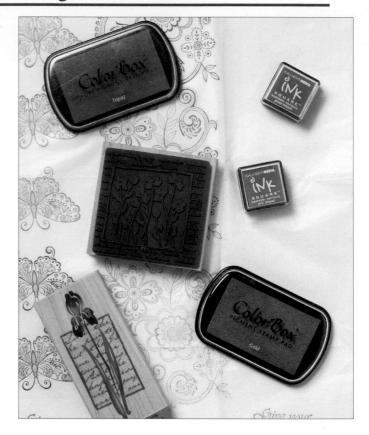

How to Heat Emboss

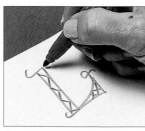

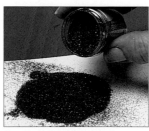

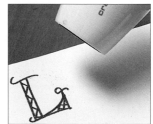

1. Write the letter or design with an embossing pen. You could also stamp a design using embossing ink.

2. Shake embossing powder over the wet ink.

3. Shake off the excess embossing powder.

4. Heat the image with a heat tool until the embossing powder melts and makes a raised, shiny surface. Let cool.

Photo on page 49: A brush with embossing ink was used to write holiday greetings on cards and a tree ornament. Gold embossing powder created the metallic, textured effect. Embossing on paper by Patti Peterson, glass and ball by Susy Ratto.

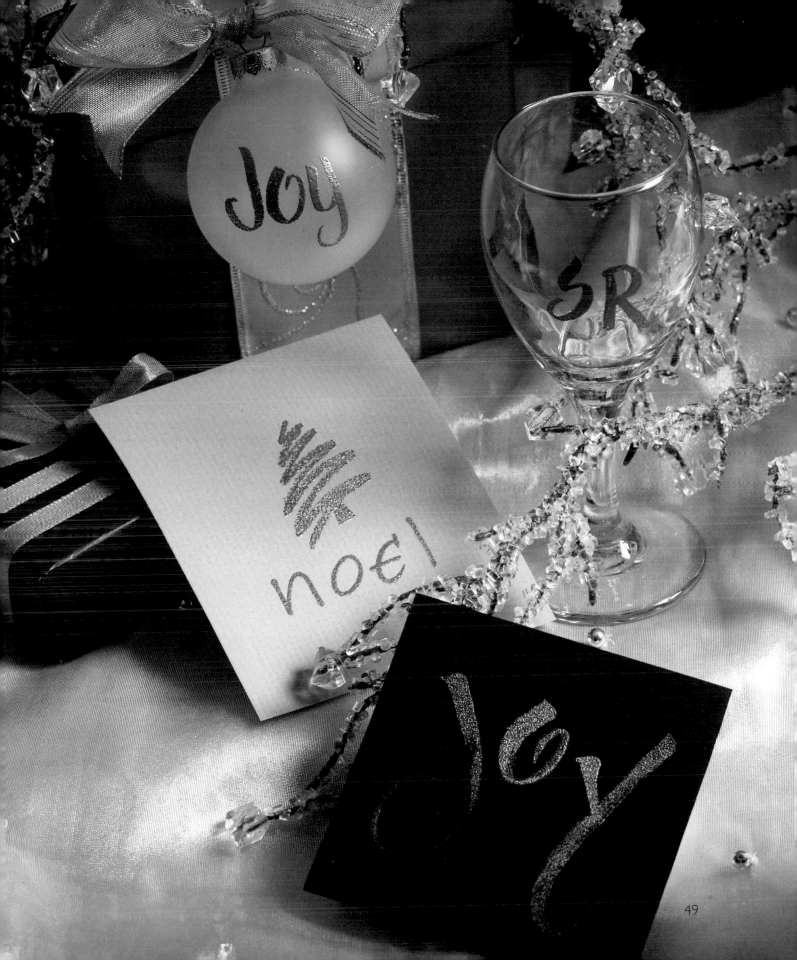

Decoupage

Decoupage is the technique of attaching papers and other decorative elements to a surface and then sealing the item with a decoupage medium. It is a great way to decorate fronts of scrapbooks, albums, and books, as well as creating wonderful pieces of art or keepsake boxes. You can use your hand lettering to enhance any of these projects.

How to Decoupage

1. Choose a surface such as a painted box, scrapbook cover, book cover, a canvas, etc. Make sure the surface is clean and dry.

2. Choose papers to attach to the surface. Papers can be cut or torn. Place the paper designs face down on a piece of waxed paper and brush the backs with a thin coating of the decoupage medium.

3. Place the paper designs onto the surface. Using your fingertips or a brayer, smooth the papers to remove any air bubbles. Allow to dry thoroughly

4. Using a brush, coat the surface with the decoupage medium to seal all the paper designs. Allow coat to dry. Apply as many coats of finish as you desire.

Create pieces of art by decoupaging designs to canvas board. Use hand lettering to decorate the pieces.

Howdy Do!

and the SEASON
TURN TURN TURN

D

• Dad •
65 • And Still Going Strong
• 2006 •

Yosemite Falls

MEMORIES
Y • S • E • M • I • T • E

Look AT ME !!!!!!!!

hi Grammie:
I grew
a beard
and i
think
i look
great.
Luv...... nathan

51

Changing Letter Shapes

Try varying the letters as shown in the exercises on these two pages. See what happens to your writing when you make a variation in the basic form of the letters. The easiest way to vary the letterforms is to try four basic changes in proportions. First, make letters tall and narrow, then make them short and wide. Try stretching the letters. Add some curly or rounded forms. Mix styles for interesting contrast.

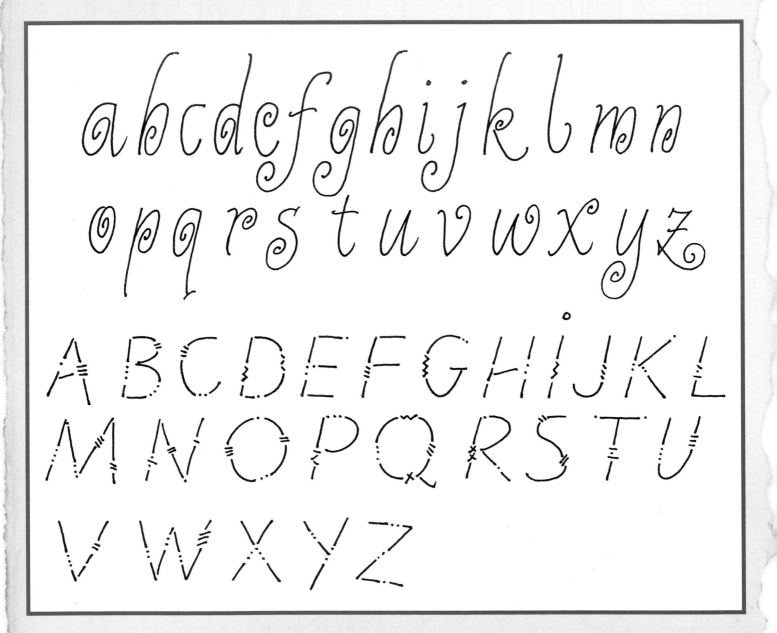

Try writing short, wide & thin

mary had a little lamb
his fleece was white
as snow. and everywhere
mary went the lamb went

Try writing short, wide & fat

mary had a little lamb
his fleece was white as
snow and everywhere
mary went the lamb
was sure to go

Push the Boundaries of Letters

All exemplars by Carrie Imai

Try writing tall & narrow

Jack Spratt could eat no fat
His wife could eat no lean
And so between the two of them
They licked the platter clean

Try mixing it up

one of the advantages
of being disorderly
is that one is
constantly making
Exciting
Discoveries

Brush Italic

This alphabet is written with a round brush or a brush marker. The size of the brush will determine the size of the letters. When using a brush, ink or very thin paint is used to load the brush. Brush markers are available in a wide variety of colors, with no need to load the brush. Markers make lettering very easy. Painters love this alphabet because they are very adept at handling a brush.

When using a paint brush, the thicks and thins of the letters are achieved by changing the pressure exerted on the brush. Also, the point can be used to make very thin strokes. Purchase a high quality brush for best results. A brush marker is the shape of a brush, but it is made of a solid fiber and it does not have individual hairs; adding pressure will not change the size of the stroke.

Above, photo album cover with painted letters and flowers by Susy Ratto

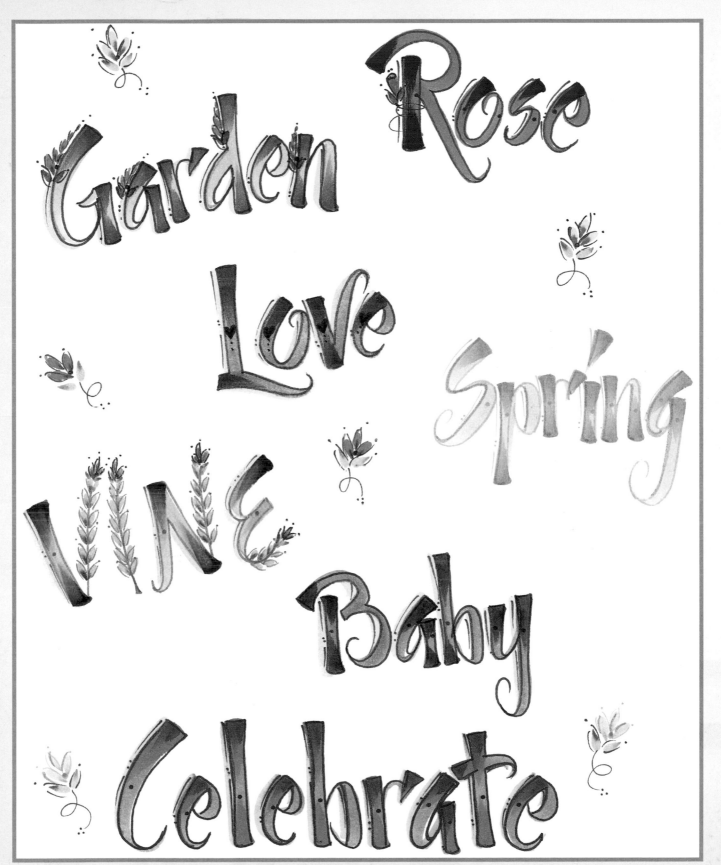

Artist, Susy Ratto

Decorating Letters with Fern

Step 1

With the brush tip of the brush marker, create the brush stroke portion of the letter shape.

Step 2

Use a 1.0 monoline writer marker to draw in the fern stems.

Step 3

With the side of an ink filled brush or brush marker, use a *stamping* technique to add leaves to the stems.

Step 4

Use a contrasting marker color in the same *stamping* technique to add flowers petals to the top.

Step 5

To outline the letter shapes and add details to the leaves and flower petals, use a 1.0 monoline marker. It adds a bit of pizzazz to use a different texture such as metallic for this step.

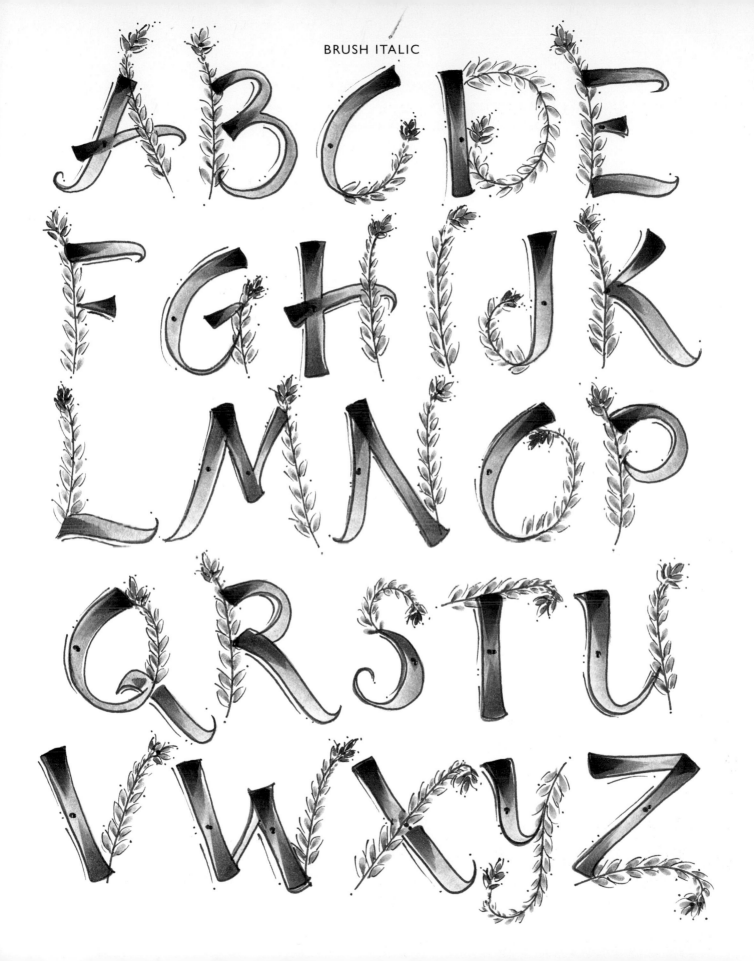

Chunky Neuland Alphabet

Write the letters with a wide chisel-style marker for one variety of letterform as shown by the exemplar on the following page. Do each stroke in a different color for a bit of mirth. If you like to work with a brush, you will enjoy writing these letters with a broad-edge brush. Another letterform can be created by drawing in the outline with a monoline marker, then filling in the letters with color, photo images, or patterns.

This alphabet is adapted from the upper-case typeface called Neuland by Rudolf Koch who designed a number of typefaces. This hand is associated with the calligraphic renaissance of the early twentieth century. The style is particularly rewarding for the beginner since it is not very detailed and will give quick success. It is a very legible hand with a bold style.

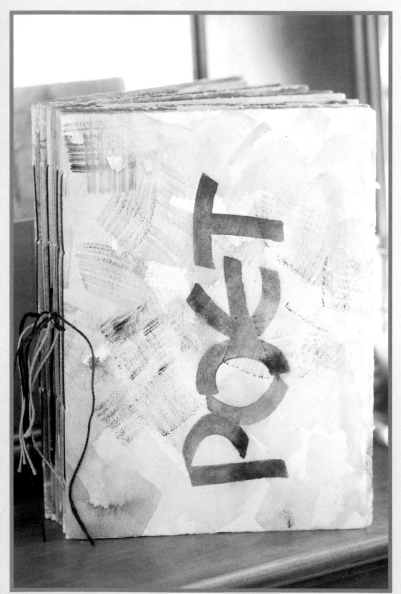

Lettering with brush and watercolor for poetry book by DeAnn Singh

IT'S A BOY!
AND
HE'S A CUTIE

NEULAND

A B C D E
F G H I J
K L M N O
P Q R S T
U V W X
Y Z · € Ч Ц

Letters done with 5mm calligraphy marker by Melissa Dinwiddie

NEWLAND

A B C D E
F G H I J
K L M N O
P Q R S T
U V W X
Y Z . - E Y U

Outline letters made with monoline marker by Melissa Dinwiddie

Notice the subtle s-curve

• • •

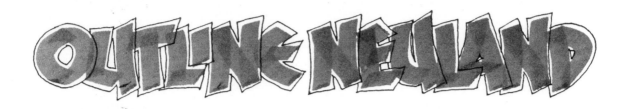

Allow letters to bump and overlap

• • •

Neuland needs no guidelines

THIS STYLE OF NEULAND IS VERY FORGIVING TO WRITE PLUS: NO LINES REQUIRED!

THE QUICK BROWN FOX JUMPED OVER THE LAZY DOG!

Lettering on this page made with 5mm calligraphy marker by Melissa Dinwiddie

76

Right: These paper cuttings were created by Sylvia Kowal. To create this same look, trace letters from the exemplars onto paper. Make sure the letters are touching. Transfer them to colored paper. Use a craft knife with a really sharp blade (#11) to cut out around the letters. Be sure the blade is sharp so you have clean-cut edges and not torn, frayed lines. You can place this cut out on top of colored papers or patterned papers for the most wonderful effects.

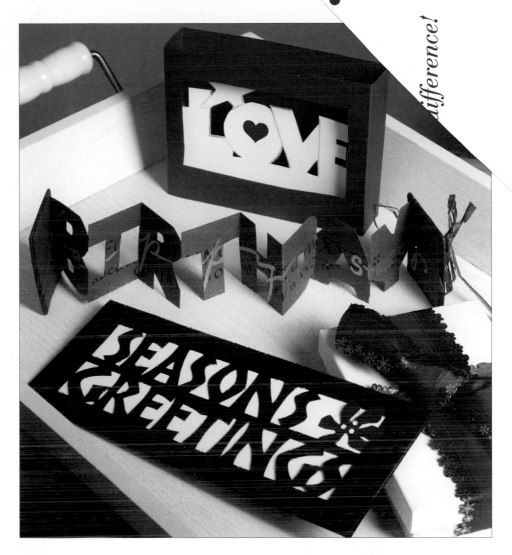

Below: The front of a scrapbook made from artisan paper is decorated with the Chunky Neuland alphabet. The letters were transferred onto the album front and outlined with dimensional paint. When paint was dry the letters were filled in with watercolor paints.

Draftsman Alphabet

Use any monoline tool such as a pencil, any roll ball, or felt-tipped marker to do this lettering. It is helpful to write with guidelines to keep the lines of writing straight and the x-height even. This style is easy to read and quick to write. It is a good choice for journals and scrapbooks.

The alphabet looks best along straight lines. It is particularly interesting how the letters fit into each other along the way. The letters are tucked into each other with some ascenders or descenders, particularly T and Y, going outside the norm to give the hand its stylized look. Notice that some of the letters are at an angle that gives style to the overall block of writing. Some of the tops of the letters like K and R are larger than the bottoms.

Being a lover of the Arts and Crafts movement, I am particularly fond of architectural-style lettering. Designers of homes and furnishings, and the art of early 1900 used this alphabet. This hand was taught to all architectural and drafting students prior to the use of the computer.

THIS BIG?

WE'RE GOING TO NEED A BIGGER SHOVEL!

NOVEMBER 2007 DAVID CREATED THIS SET TO HANG A FORD TRUCK UP BY ITS TOW HOOKS

AFTER

BUILDING A FORD COMMERCIAL SET

BEFORE THE REMOVAL OF 2,128 sq YDS OF DIRT

KINDLY RESPOND BY JANUARY 13

__WILL ATTEND __WILL NOT ATTEND

YOUR NAME (

MICHAEL

ONSIEUR ET MADAME JOURFAIT
CHATEAU DOUBLE BAT 5
ZAC APPT. 350
AIX EN PROVENCE, FRANCE
1 3 0 9 0

SIGNATURE BIRTHDAY DINNER

MISE BOUCHE
GOAT CHEESE PANA CATTA TART
PICKLED BABY BEETS
CANDIED GINGER AND MACHE

FIRST COURSE
ARTICHOKE SOUP
WARM TRUFFLE BRIOCHE
TRUFFLE BUTTER

SECOND COURSE
PEKEE TOE CRAB & LOBSTER NAPOLEAN
GRAPEFRUIT EMULSION

INTERMEZZO
POMEGRANATE GRANITE MARTINI
GREY GOOSE

ENTRÉE
LAMB NICOISE
OVEN ROAST TOMATOES
CANDIED EGGPLANT
CRISPY POTATOES, PEQUANT CAPERS
NICOISE OLIVE LAMB SAUCE

DESSERT
"DING DONG"
CHOCOLATE SPONGE CAKE
"VANILLA FLUFFER"
VAHLARONA CHOCOLATE GANACHE

DRAFTSMAN:

A B C D E F G H I
J K L M N O P Q
R S T U V W X Y Z

ALTERNATES:

A A C E K O P S Y

PARTICULAR FEATURES:

A, E, F - CROSSBARS
K, R - HEAVY TOPS
G, O, Q, S - NOT ROUND, SLANTED
B - BIG BOTTOM
M, W - SMALLER FIRST PART
T, Y - LONGER TAIL

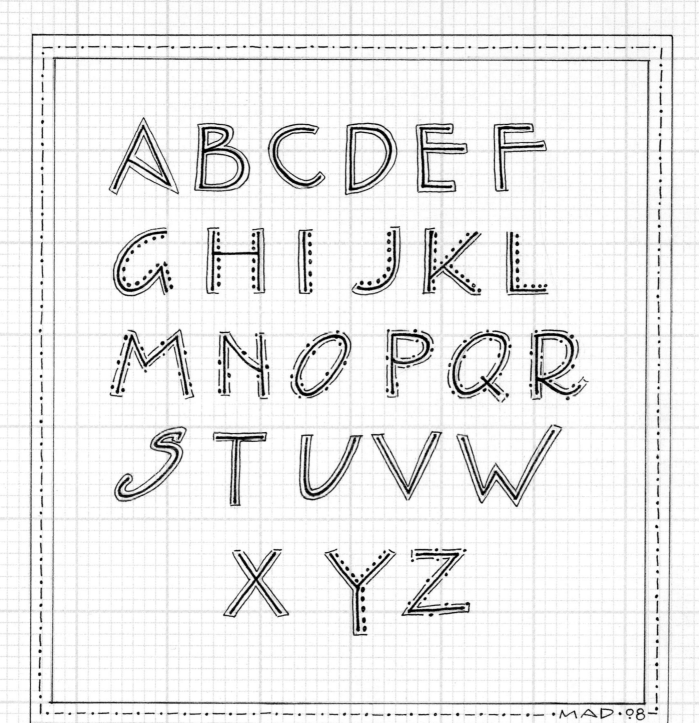

ABCDEF
GHIJKL
MNOPQR
STUVW
XYZ

MAD·08

1234567890

Bungalow Alphabet

This is another monoline alphabet that can be written with any monoline writing tool. The decorative elements of the letterform, such as the double or triple crossbars, and the vertical dots of some letters, give the alphabet style and allow for colorful interpretations. Writing the alphabet with a chisel-type marker gives another look to the lettering.

This alphabet is an interpretation and version of the alphabet designed by Charles Rennie Mackintosh in collaboration with his wife Margaret MacDonald Mackintosh. Mackintosh was a Scottish artist and architect of the early 1900s who was very influential in the Arts and Crafts movement.

HOME

WILSHIRE PARK

US

OUR HANDPRINTS

ABCDEFGHIJKLMN

OPQRSTUVWXYZ

"Width Groups"

W: as wide as tall
MVX: 65%
ANQYZ: 60%
BCDGHKORSTU: 45%
LP: 40%
EF: 35%
J: 25%
I: width of tool

"Intersections" top to bottom

OY 55%
ABGHKMNPRSWX 33%
EF 20%

Exemplar by Carol Pallesen

These letters were written with a chisel-type marker.

BUNGAL:W:

A B C D E F G H I

J K L M N: P Q R S

T U V W X Y Z

1 2 3 4 5 6 7 8 9 0

VARIATIONS:

A̲N̲D̲ T̲O̲ LA LE LL OE TH TT Ẅ

AT F:R M::N CERAMIC DETAILS

L:S ANGELES • CALIF:RNIA • 9::::5

mad '08

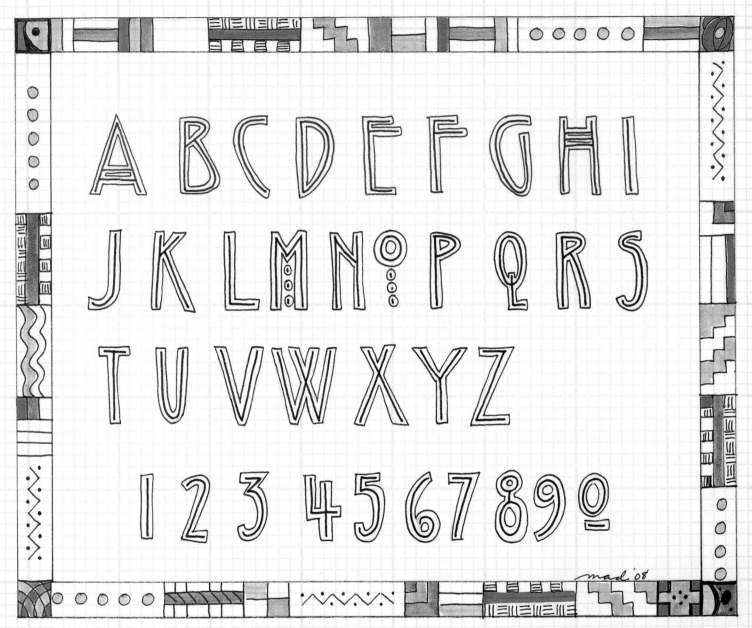

Exemplars written with 1.0 monoline, border made with .005 monoline

BORDERS

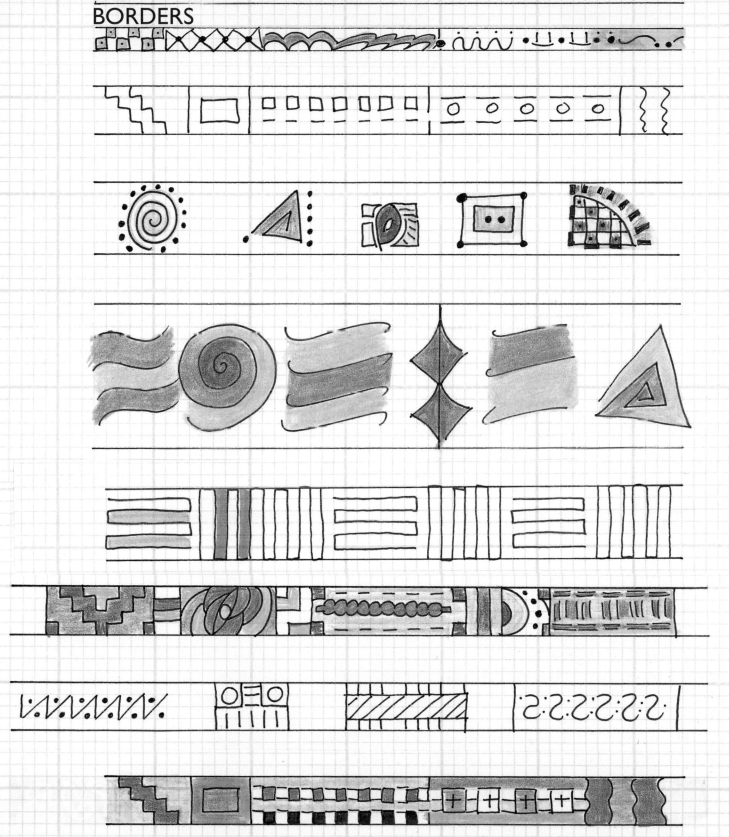

Druid Alphabet

The Druid alphabet is executed with drawn letters. The exemplars on the following pages show the alphabet, drawn by Jane Shibata, in a skeletal version as well as built up letters. Trace the letters needed from the examples, then transfer them to your surface. Use a monoline marker to draw in the skeletal letters. You can fill in the outlines with color or patterns to finish the letters. This alphabet is best as only capitals. These capital letters are perfect for creating monograms that are decorated, then placed on memory books, scrapbook pages, cards, pins, small boxes, or framed as art.

This alphabet is influenced by the Uncial and Lombardic alphabets. Some of the best examples of these styles are in the titling of illuminated manuscripts, The Book of Kells, and shapes from fantasy art.

Pictured on page 89, illuminated letters by Jane Shibata

DRUID

A MEMBER OF AN ANCIENT ORDER OF PRIESTS IN BRITAIN AND GAUL WHO DRESS IN LONG, DARK CAPES WITH LARGE HOODS AND SOMETIMES SMELL OF OIL OF PATCHOULI. THESE ANCIENT CELTIC PRIESTS APPEAR IN WELSH AND IRISH LEGENDS AS PROFITS AND SORCERERS.

89

MONOLITH

A B C D
E F G H I
J K L M
N O P Q
R S T U
V W X Y Z

·Jane Shibata·

SCABBARD

A B C D
E F G H I
J K L M
N O P Q
R S T U
V W X Y Z

-Jane Shibata-

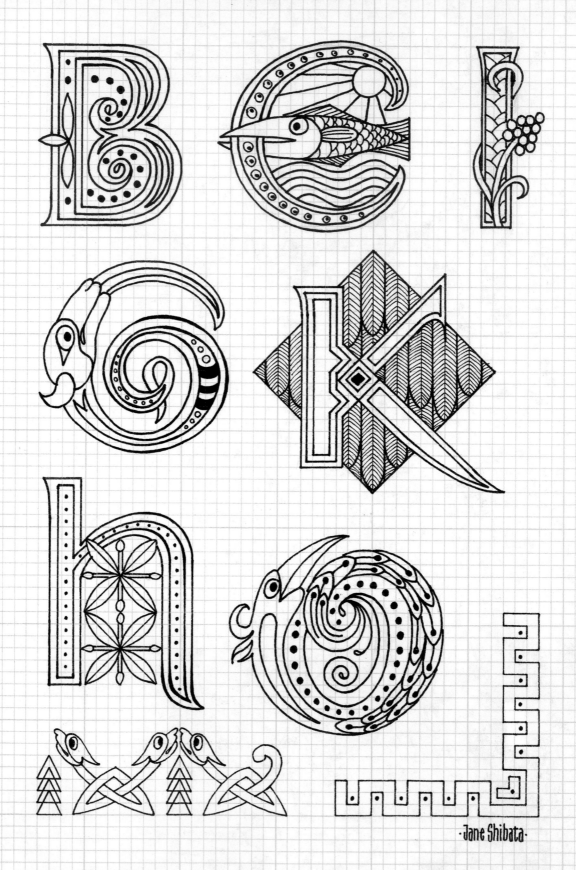

-Jane Shibata-

92

DESIGN ELEMENTS

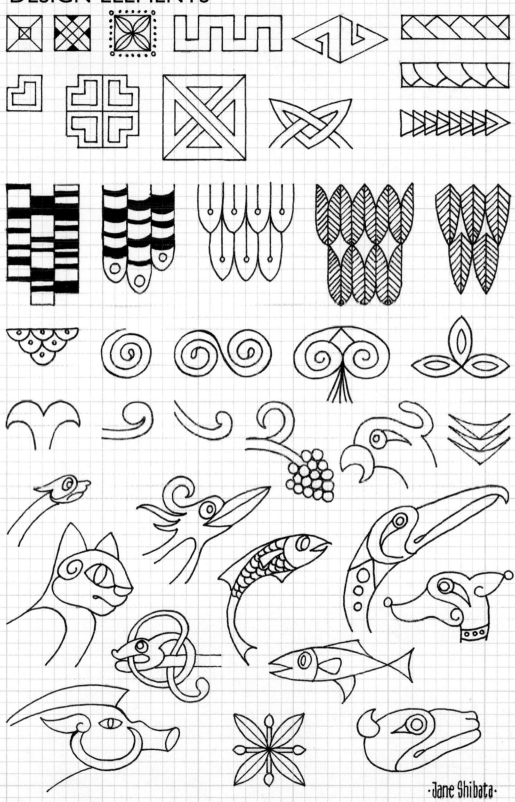

·Jane Shibata·

Summer of Love Alphabets

The exemplars of this alphabet feature two outlined forms. The alphabets are based on a rounded Neuland form and a variation on that theme. Use a monoline marker to draw in the outlines. Fill in the outlines with color or design.

The influences of the sixties are still and will always be a part of our culture. This alphabet was influenced by the poster art, record album covers, psychedelic art, and paisley designs of that era. Some artists that influenced this period are Musha, Rick Griffin, and graffiti artists. Today we can still see this art influence on skateboards and surf art.

Pictured on page 95, greeting cards by Karin Gable and Carrie Imai

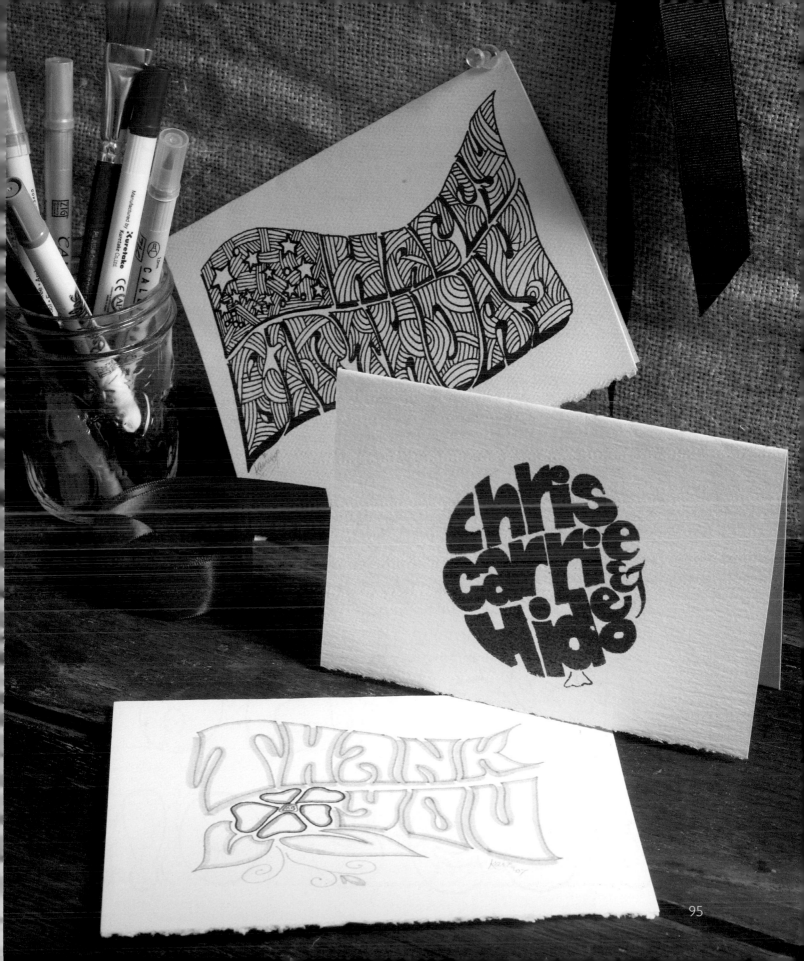

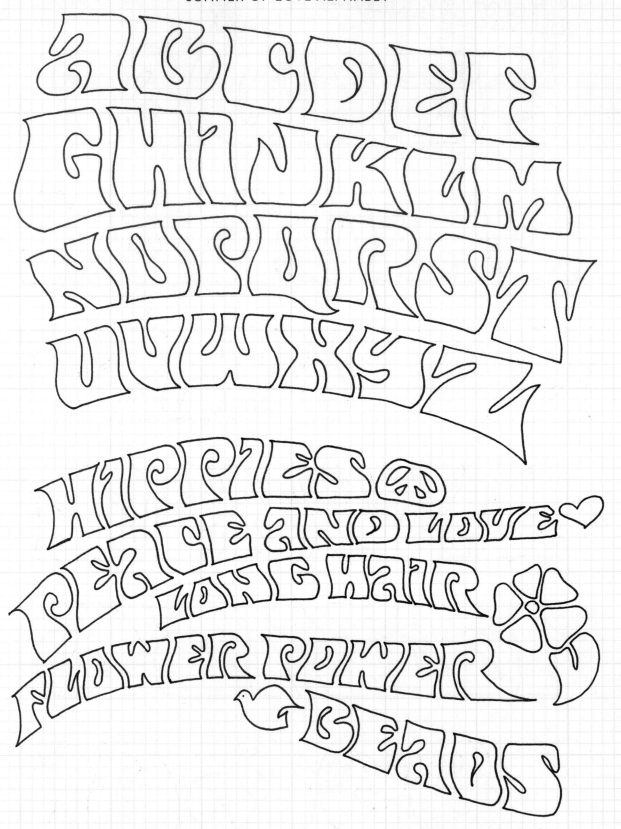

ABCDEF
GHIJKLM
NOPQRST
UVWXYZ

HIPPIES
PEACE AND LOVE
LONG HAIR
FLOWER POWER
BEADS

karin gable

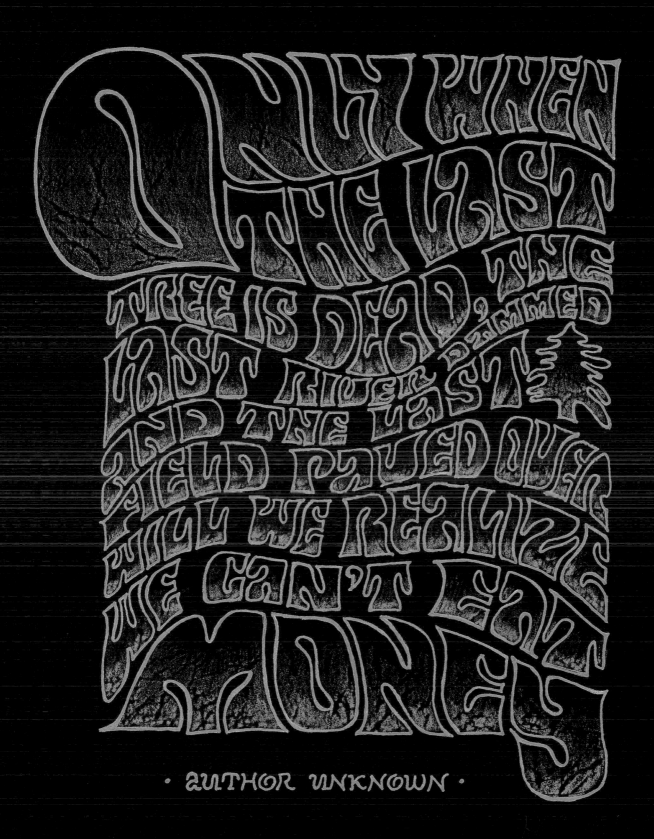

ONLY WHEN THE LAST TREE IS DEAD, THE LAST RIVER DAMMED AND THE LAST FIELD PAVED OVER WILL WE REALIZE WE CAN'T EAT MONEY

· AUTHOR UNKNOWN ·

Ribbon Writing Alphabet

This is another drawn alphabet by Karin Gable. Trace the letters you need from the exemplar onto tracing paper. On a copier, enlarge or reduce the lettering to the size needed for your project. You can then transfer the words to your surface. Use a monoline marker to draw over the skeletal outline of the letters. Fill in the letters with your choice of color.

This alphabet has free-flowing lines which simulate twisted ribbon. It is best to use this alphabet for situations when only one or two words are needed for a project.

Colored pencil and marker lettering by Karin Gable

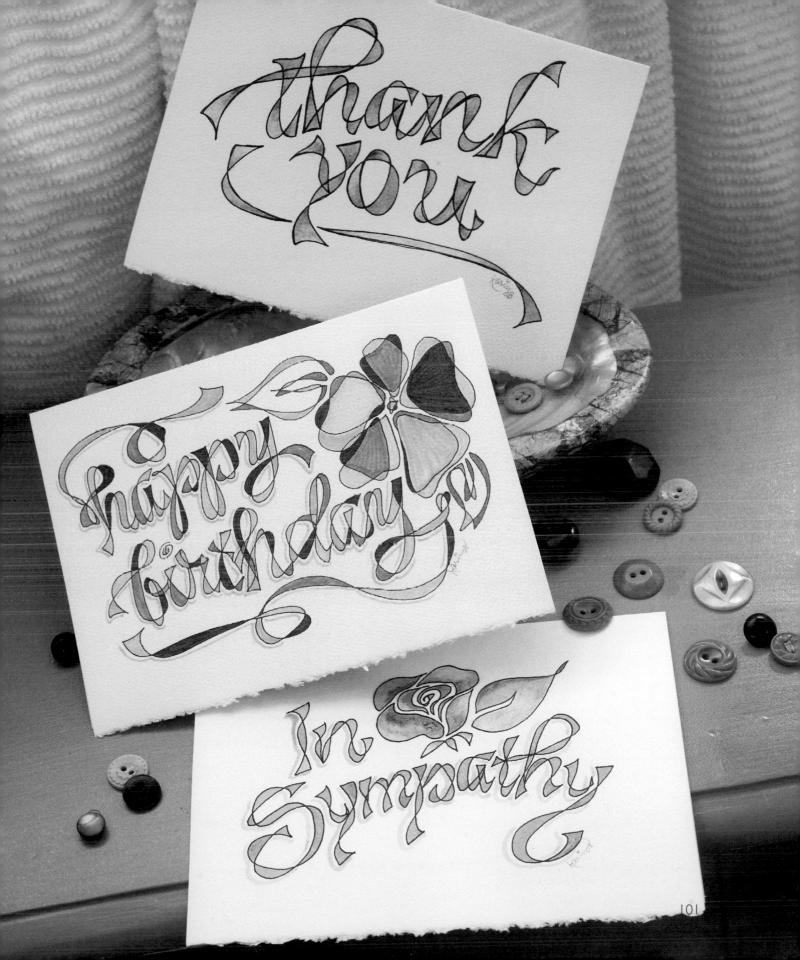

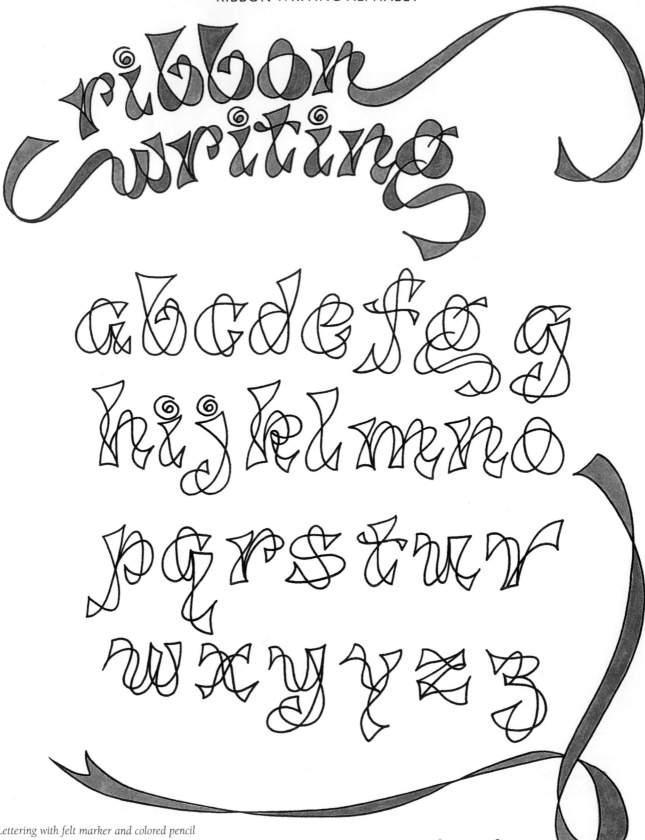

Lettering with felt marker and colored pencil

karin gable

Drawing Your Own Alphabet

1

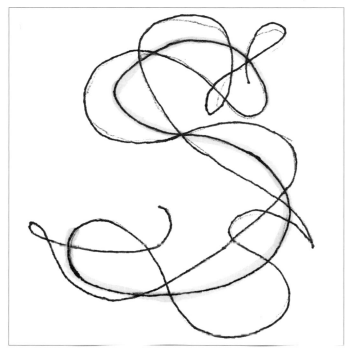

Step 1

Use pencil to draw your letter with a flowing movement. Then draw lines around that letter and intersecting through the letter, making loops and curves. Be aware of the shapes you are creating, making some large and some small. Erase and fix some shapes and lines as needed. When it's the way you want, trace it onto your surface.

Step 2

Draw over the transferred lines with a permanent monoline marker. Color in the shapes with a marker or paint.

Step 3

To create a unique monogram, add a border. Fill in around the outside of the letter with color.

2

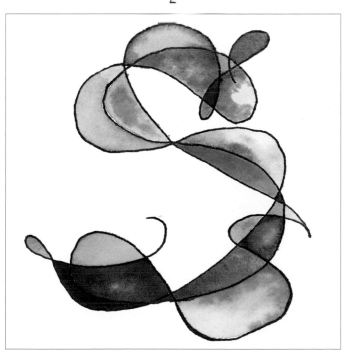

3

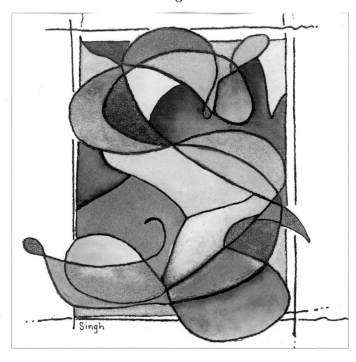

Singh

Lettering with pencil, felt marker, and colored marker

Chip Kickin'

Two alphabet exemplars are included for this theme. *Saloon* can be lettered with a chisel-tip pen, or it can be traced from the example and drawn in. *Lasso* is a drawn alphabet that you can trace from the example.

The influence for creating these alphabets came from the cow-boy shows and books of the 1950s and 60s. It seems my childhood was full of playing cowboys with my trusty horse taking me wherever my imagination wanted to go.

SALOON LowerCase

abcdefghijk

lmnopqrstu

vwxyz

1234567890

SINGH

ABCDEFGHIJKL

MNOPQRSTUVW

XYZ &

SINGH

Singh 2008

This alphabet is based on the typeface Barnum that was first seen in 1817. It was the first of a style of type named Egyptian that had slab serifs. Many fonts have evolved from this style to be bold and brash. It is meant to grab attention. During the Industrial Revolution the Barnum font was used extensively in advertising.

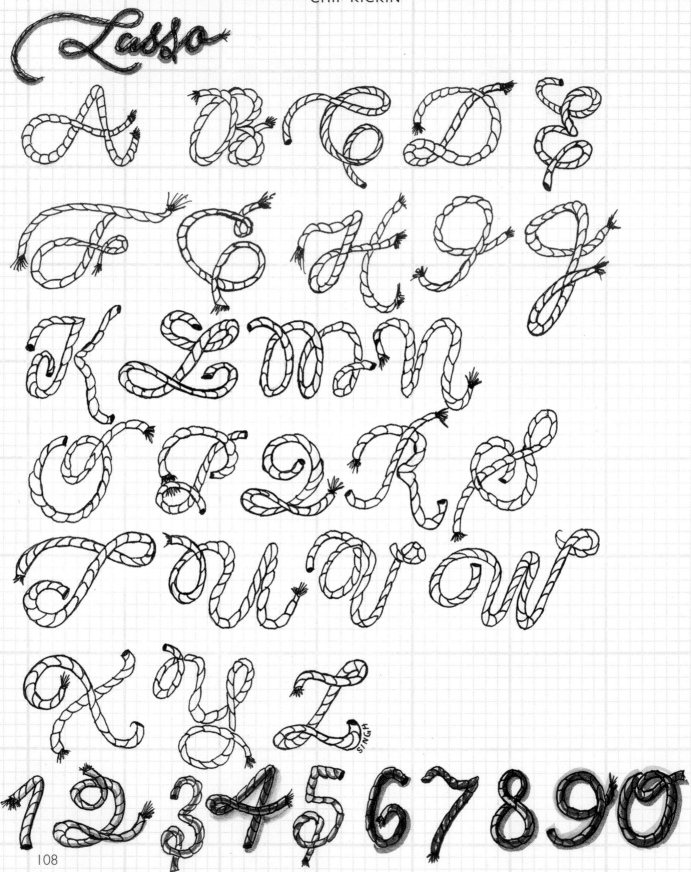

Draw with pencil.

Outline with thin black pen.

Color with thicker black pen.

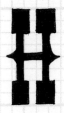

Use thick black pen to shadow the right and underside.

Variations with peaks drawn on the tops and bottoms.

Variation with spurs drawn on both sides of the letter

Variations:

1. *Add rivets to the lines*
2. *Create wood grain with screws*
3. *Draw black wood grain running vertically and color in with brown and gray.*
4. *Draw wood grain running vertically.*
5. *Draw wood grain running horizontally.*

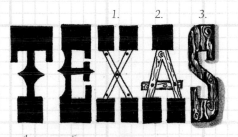

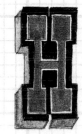

Three-dimensional letters:

1. *Draw the letter.*
2. *Make an outline around the letter.*
3. *With gray, draw a dimension shadow at left and bottom*

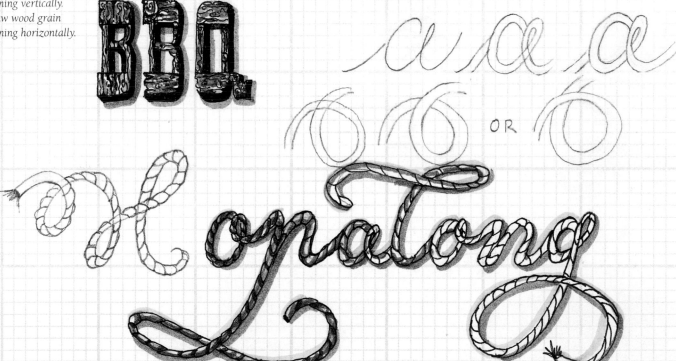

To construct any word into Lasso writing, start with cursive script that is based on your own handwriting. It works best if you build it letter-by-letter instead of writing the whole word and filling it in afterwards.

1. *Use pencil to write the letters.*
2. *Mirror that stroke with a parallel line to create the rope.*

3. *Erase some lines to create an over/under pattern.*
4. *Draw in the rope segments, making the segment lines curved.*
5. *Use a thin black marker to draw over the pencil lines.*
6. *Color the rope with yellow and brown. Add a gray shadow under the letter for a touch of three-dimension.*
7. *Add some frayed ends to the rope letters.*

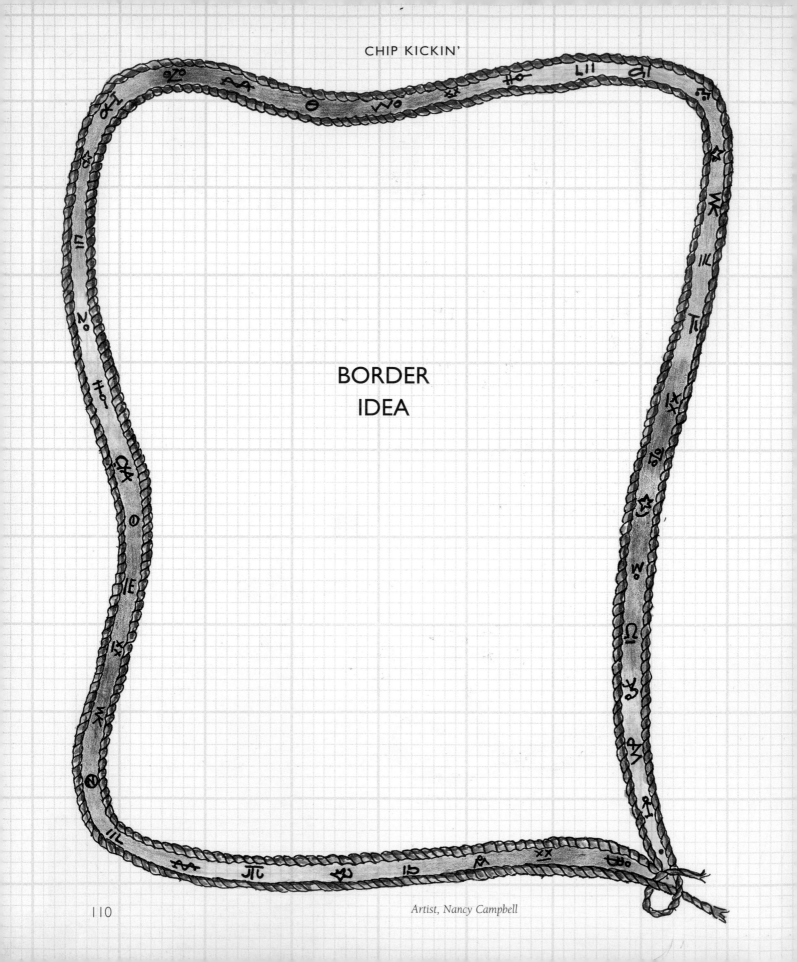

BORDER
IDEA

Artist, Nancy Campbell

Clothesline Alphabet

This alphabet is based on Roman letters that are modified and freely written, and then are strung together by horizontal lines. Use a monoline pen to make the letters. Connect the letters with horizontal base lines. Fill in with color.

This alphabet gives new meaning to the phrase "reading between the lines." These are whimsical letters with movement that are so much fun to do.

Artist, Carol Pallesen

CLOTHESLINE CAPS

AAAABBBCCCDDDEE

EEEFFGGGGHHHHIJJ

KKKLLMMMNNNOOOO

PPQQQQRRRSSTTUU

VVVWWWWXXYYZZZ

&&&0123456789 CAROL PALLESEN

Example with monoline markers by Carol Pellesen

Step 1

Write the letters with a waterproof monoline pen.

Step 2

Join the top and bottom of the letters to form the clothesline.

Step 3

Use watercolor pencils to shade the right side of the letters.

Step 4

With a small flat brush loaded with a little water, pull color to the left side of the next letter.

Here's how to create an interesting piece of lettering by writing between the lines.

Step 1

Draw some pencil lines. Make them wavy.

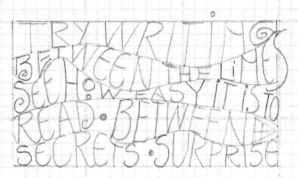

Step 2

Write the words of your choice between the lines, using pencil. Touch the line with the letters.

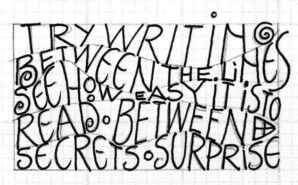

Step 3

Ink over the penciled letters. Do not ink the lines.

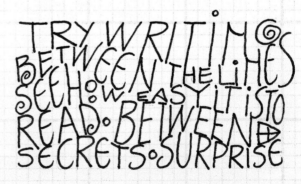

Step 4

Erase all pencil lines for interesting results. Add color to your lettering as desired.

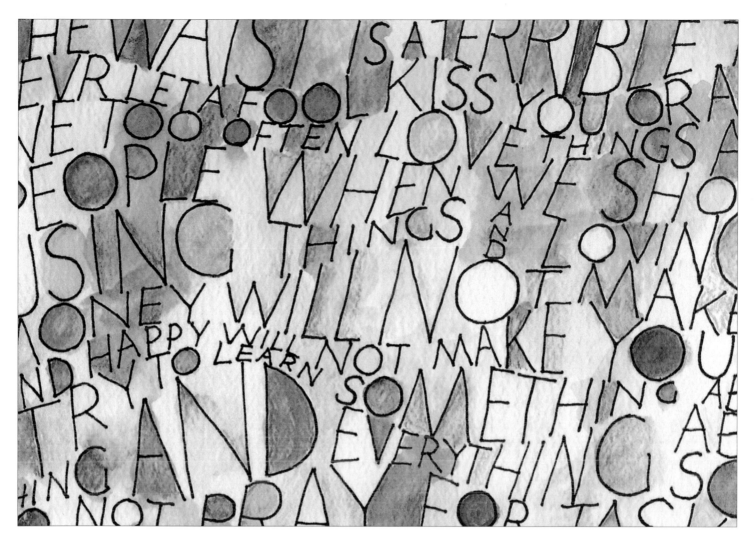

Above: Color was added inside and between the letters with watercolor pencils. A damp brush was used to blend the colors together. Artist, Helen Chu.

Right: The wavy pencil lines can be inked if you wish. Artist, Helen Chu.

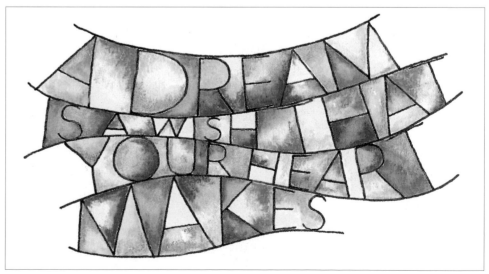

PAINTING BETWEEN THE LINES

Here's a wonderful project that combines painting between the lines with your handwriting. This is a great idea for a greeting card as well as a piece of framed art.

Step 1

Using a pencil, draw a square or rectangle. Fill the area with wavy pencil lines.

Step 2

Pick two colors of small chisel-tipped markers or a brush and two colors of paint. Alternating the colors in any pattern you choose, make comma-shaped marks across the first line. On the second line, make C-shape strokes to finish out the lines. Continue until the space is filled.

Step 3

Using your own hand-writing and a monoline marker, write the message around the edges of the square. Your writing will look like fringe. Turn the page around as you write.

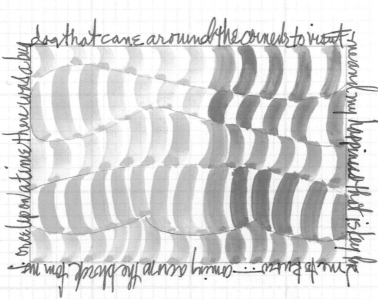

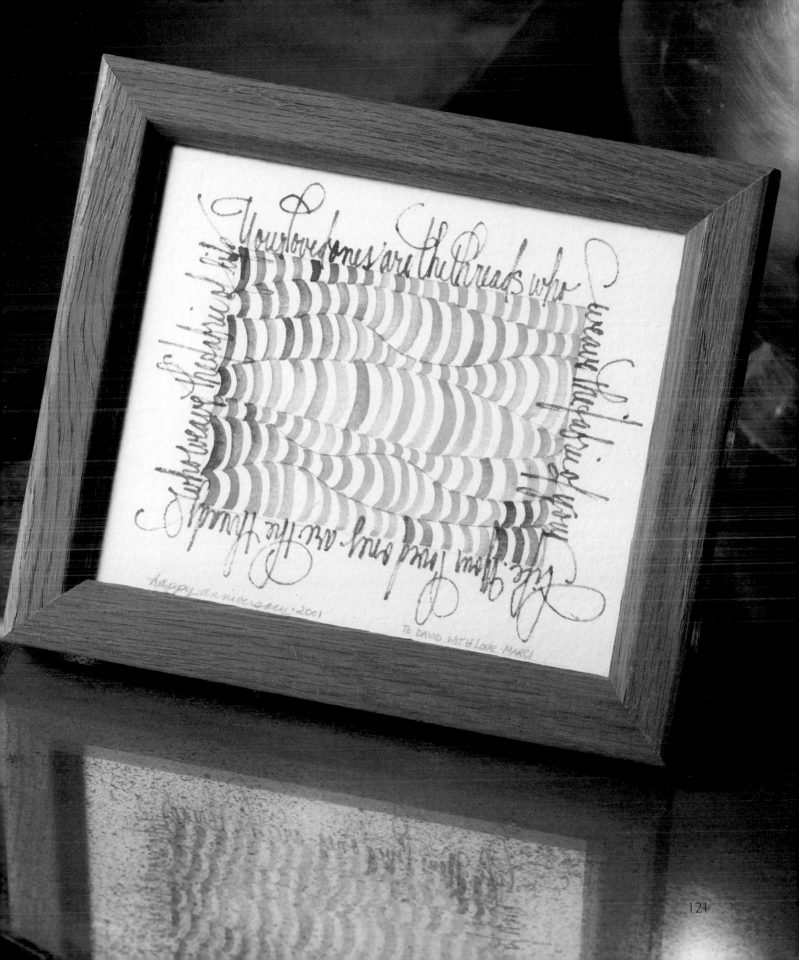

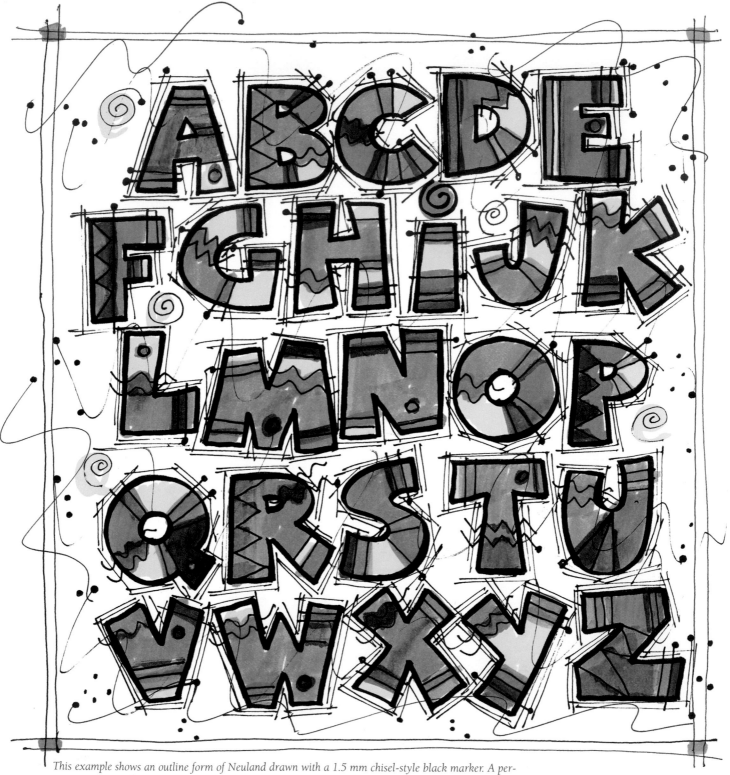

This example shows an outline form of Neuland drawn with a 1.5 mm chisel-style black marker. A permanent ink monoline marker was used to draw designs inside the letters such as stripes, zigzags, wavy lines, circles, and triangles. Design areas of the letters were colored in with markers and highlighters.

Artist, Sylvia Kowal

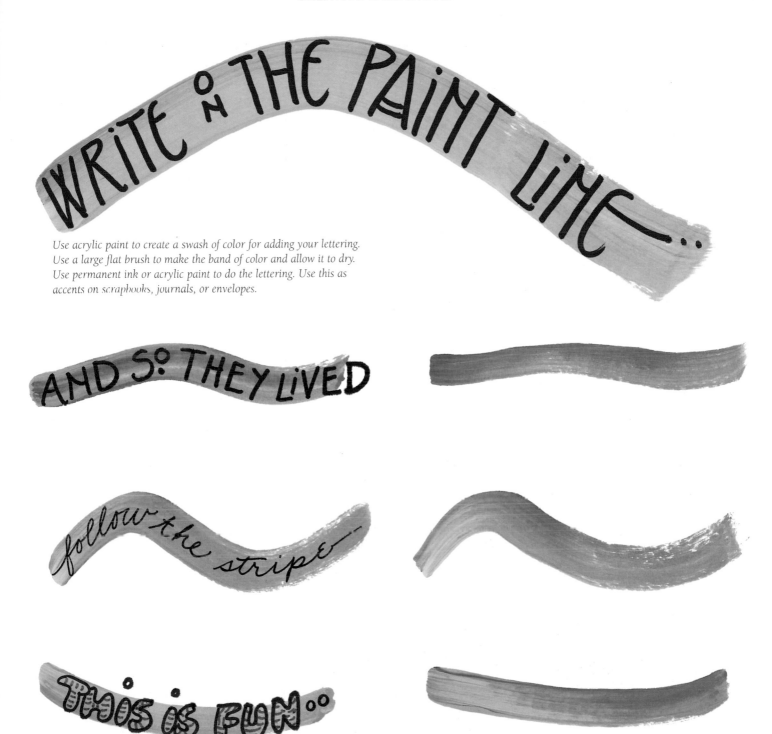

WRITE ON THE PAINT LINE...

Use acrylic paint to create a swash of color for adding your lettering. Use a large flat brush to make the band of color and allow it to dry. Use permanent ink or acrylic paint to do the lettering. Use this as accents on scrapbooks, journals, or envelopes.

AND SO THEY LIVED

follow the stripe...

THIS IS FUN..

PERFECTION

BORDER IDEAS

by Melissa Dinwiddie

About the Authors

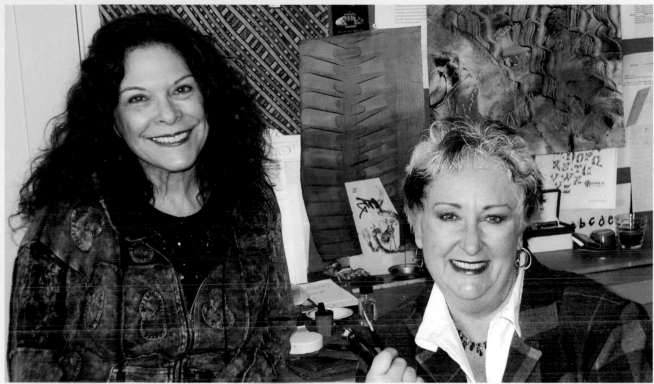

Pictured from left: Marci Donley, DeAnn Singh

At a time when **Marci Donley** was looking for the next step to take in her life, she decided to take a calligraphy class. Her teacher was DeAnn Singh, who taught her the art of calligraphy, became her mentor and friend, then the co-author of this book.

Marci is a career calligrapher for the Supervisors of Los Angeles County. She teaches calligraphy and rubber stamping, is a One Stroke Certified Instructor, and an Ambassador for Plaid Enterprises, Inc. Marci is the co-author (with Mickey Baskett) of *Greeting Cards Galore* (Sterling, 2004); and authored *Simple Stroke Calligraphy* (Sterling, 2006).

Marci loves to combine her love of arts and crafts with her calligraphy expertise. She entered the world of crafts unsuspectingly when she was asked to help out at a gift trade show for All Night Media, a rubber stamp company. That invitation was the beginning of a full-time passion.

Marci is a native of Los Angeles where she and her husband, David, share a California Craftsman home. She is the proud mother of two sons.

DeAnn Singh is a lettering artist from Los Angeles, California. Her studio, *Designing Letters*, is home to calligraphy classes of all levels. She has been teaching calligraphy for 27 years throughout the Los Angeles area, including Beverly Hills Unified and Los Angeles Unified school districts.

She works for the County of Los Angeles Supervisors, lettering certificates and other formal documents. She also does custom work such as wedding and party invitations; movie and television props. Her most prominent work has been for the T.V. show *Charmed*, and movie *National Treasure, Book of Secrets*.

DeAnn has loved handwriting since she learned printing and cursive handwriting in school. She has since studied with prominent calligraphers from around the world and is considered a Master Calligrapher.

She is the wife of Ray and mother of Jonathan, Donavan, Hailey, and grandmother of Jonathan Jr., Kameron and Nathan.

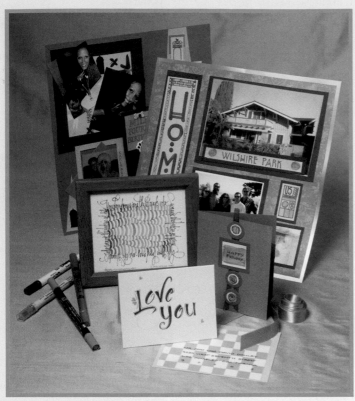

Projects by Marci Donley, DeAnn Singh, and Susy Ratto

We are lucky to be able to include the work of artists that we admire. Thank you all for producing work for this book and letting us use your examples.

Nancy Campbell
Helen Chu
Melissa Dinwiddie
David Donley
Marci Donley
Lisa Engelbrecht
Karin Gable
Joan Hawks
Gayle Hatton

Carrie Imai
Sylvia Kowal
Carol Pallesen
Patti Peterson
Susy Ratto
Renee Troy
Jane Shibata
DeAnn Singh

Index